IMAGES of America
IRISH PITTSBURGH

ON THE COVER: The staff of the Conemaugh Division of the Pennsylvania Railroad poses on a railroad car at the Verona Yards on October 23, 1914. (See page 32.) (Courtesy of Hays family.)

IMAGES of America
IRISH PITTSBURGH

Patricia McElligott

Copyright © 2013 by Patricia McElligott
ISBN 978-0-7385-9791-1

Published by Arcadia Publishing
Charleston, South Carolina

Printed in the United States of America

Library of Congress Control Number: 2012942759

For all general information, please contact Arcadia Publishing:
Telephone 843-853-2070
Fax 843-853-0044
E-mail sales@arcadiapublishing.com
For customer service and orders:
Toll-Free 1-888-313-2665

Visit us on the Internet at www.arcadiapublishing.com

*In loving memory of my parents,
John James McElligott Jr. and Margaret Martin McElligott.*

Contents

Acknowledgments		6
Introduction		7
1.	Coming to America: "Disquieted Folk"	9
2.	Work: "They Each Wheeled Their Barrow"	23
3.	Family: "Her Good Ould Irish Way"	43
4.	Religion: "The Binding Force"	61
5.	Social Life: "Bacon and Tea"	81
6.	The Military: "A Soldier's Song"	103
7.	Personalities: "A Triumph for Irish Americans"	113
Bibliography		127

Acknowledgments

I want to thank the following individuals and families who donated their photographs, memories, and time to *Irish Pittsburgh*: Eileen Aquiline, O'Shea family, Mary Lou Conroy, Carmen J. DiGiacomo of Photos by Como, Amber Savka, Hays family, John McInerney family, John Haltigan, Nolan-Haller family, Stack-Clark family, Kathleen Quigley Rodgers, Quigley family, Brennan family, Timothy Daniel O'Brien, Cathy O'Connor, Lois O'Toole, Patricia Moorhead, David Figgins, Edward Deenihan, Schmalstieg family, Larry Squires, Anne Feeney, McElligott family, Rich Fitzgerald, Charles McCollester, and Cantwell family.

These individuals and institutions also provided photographs and support: Kenneth White, Burris E. Esplen IV, and the Diocese of Pittsburgh; Sister Patricia McCann and the Archives of the Sisters of Mercy in Pittsburgh; Father Nichols and St. Patrick-St. Stanislaus Kostka Parish; Dan Drischler and Ancient Order of Hibernians, Division No. 23; Wilkinsburg Historical Society; South Side Celtic Society; and Irish Centre of Pittsburgh. I am also grateful to Mary Anne Pischke for her original drawings and Amy Pischke for her photographs.

Bernard Hagerty's class at the University of Pittsburgh provided a historical framework for the Irish experience in America, Photo Antiquities staff explained the evolution of tintypes and cabinet cards, and the following people and organizations spread the word about this project: Jack Webber and the Gaelic Arts Society of Pittsburgh, Pittsburgh Irish Network, Chuck Peters, Lois Walsh, James Green, Father Joseph Mele, and Diane Byrnes, the producer and host of *Echoes of Erin* on WEDO 810 AM. My special thanks to Mary Frances Garrison for her diligent search for artifacts of Irish life; James and Debra Pratt, Jeff Therrien, and Paul McMillan for their technical support; and Michael R. Shaughnessy for his help in identifying historical sources. I also thank Abby Henry at Arcadia Publishing for her ongoing guidance and support.

Introduction

*Then take the shamrock from your hat
and cast it on the sod,
It will take root and flourish still, though
underfoot it's trod.*

From "The Wearin' o' the Green"
Dion Boucicault
Immigrated to America in 1853

The first Irish to immigrate in large numbers to North America were 250,000 residents, mostly from Ulster, in the 18th century. Bridling from the tyranny of their British rulers, whose Penal Laws and other oppressive legislation made life difficult for non-Anglican citizens, Irish Presbyterians and some Catholics left Ireland in the hope of finding religious tolerance and economic opportunity in the United States. Periodic famines, rising rents, and the decline of the linen trade, a staple of the Irish economy, all drove people to leave. Early immigrants came to Pennsylvania because the colony practiced religious tolerance and offered work to them. These pioneers—skilled craftsmen, soldiers, and even landed gentry—gradually migrated westward and established a trading post in southwestern Pennsylvania, the area that would eventually become Pittsburgh. Until the 1840s, it was predominantly a Protestant history.

For many Irish Pittsburghers, though, the story begins with Ireland's Great Potato Famine of 1845–1846. When blight struck the potato crop, the main source of food for Irish farmers, and relief did not arrive, the Irish started dying in the hundreds, and then the thousands. In the years and decades that followed, people emigrated to Britain, Canada, and other countries. By far the largest number, about 1.5 million of them, fled to the United States. Once here, after grueling and often deadly voyages, the immigrants settled in New York, Boston, Philadelphia, and other cities in such large numbers that by 1900 there were a half-million more Irish in the United States than there were in Ireland.

Those who made their way to Pittsburgh found a city booming with industry but unwelcoming to the desperate Irish. The immigrants settled in shantytowns and took jobs on the lowest rungs of the economic ladder as unskilled laborers and domestics because, no matter how hard the jobs were, they were better than starving. They lived in brutal poverty. In *The Valley of Decision*, Marcia Davenport's 1942 novel about the struggles of Irish immigrants in 1873 Pittsburgh, Irish-born maid Mary Rafferty describes her family's North Side shanty: "The cramped and gloomy place that had been her home. She thought about the dirt, the greasy, cindery soot, the miasmic foggy pall

that hung over the waterside, the clangor of the freight and ore cars that roared and screeched a stone's throw from her door. She thought about the endless battle with dirt and squalor." The crushing poverty created innumerable social problems. Alcoholism, deadly diseases like cholera and smallpox, mental instability, and crime overwhelmed the immigrants and threatened to destroy their American experience. Fortunately, in the years before government provided respite for the needy, the Diocese of Pittsburgh, individual Catholic churches, the Sisters of Mercy, the Ancient Order of Hibernians, and other groups emerged to help the Irish survive.

Stereotypes abound of these early Irish Americans—Paddy the sandhog and Bridget the maid—but the condescension evident in the comical titles underestimates the determination of the Irish to improve their lot. Pittsburgh was not a land of opportunity for the 19th-century immigrants, but it would prove to be just that for their children and grandchildren. These descendants rose from poverty to control city hall, run the Catholic Diocese of Pittsburgh, found a major football franchise, and excel in the arts, sports, and labor unions. Pittsburgh's Irish produced dancer-director Gene Kelly, Pittsburgh Steelers founder Art Rooney, Gov. David L. Lawrence, Medal of Honor recipient Charles "Commando" Kelly, singer-activist Anne Feeney, and other groundbreakers who shaped the region and put the Irish imprimatur on the land.

Most Irish Americans in the Pittsburgh region "merely" aspired to become more prosperous, to make a better life for themselves and, especially, for their children. Over the decades, Irish Americans moved from shantytowns and tenements to solid homes in the city and the suburbs. Every European immigrant group craved home ownership, but the Irish wanted it more than most, as if claiming a bit of land could make up for what their ancestors had lost when their farms were taken from them during the famine years. These Pittsburghers became "lace curtain Irish," the delicate drapes in their windows a sure sign of their respectability.

Protestant Irish, first known as Ulster Scots, then Scots Presbyterians, founded Pittsburgh but followed a different track and are generally considered a separate ethnic group from Irish Catholic. This book dwells on the latter, the Irish who fled famine and post-famine Ireland and their descendants, but a few Irish Protestant families are also included since Pittsburgh is their city too. This collection of vintage documents, mainly photographs, gives the reader an impressionistic, rather than comprehensive, look at life among the Irish in Pittsburgh in the late 1800s and 1900s. The first generations of Pittsburghers cultivated a passion for church, politics, Irish independence, and labor unions. Later generations, especially after World War II, identified themselves as Americans and were assimilated into the culture. They held onto some of their heritage, but left behind the Irish neighborhoods, nationalism, and other fierce commitments of their ancestors.

The survivors of famine and their progeny have earned a respected place in Pittsburgh history. These immigrants rose from despised peasants to esteemed citizens, the second-largest ethnic group in the city. *Irish Pittsburgh* honors our ancestors and resurrects their memory by offering highlights from their American experience.

One
COMING TO AMERICA
"DISQUIETED FOLK"

The vessel was crowded with disquieted folk
The escape from past hardship sustaining their hope
But as the last glimpse of Ireland faded into the mist
Each one fought back tears and felt strangely alone.

From "An Emigrant's Daughter"
Traditional Irish Folk Song

Even if the Irish had come to the United States, as historian Lawrence J. McCaffrey writes in *The Irish Diaspora in America*, "wearing linen suits and patent leather shoes, waving the American flag in one hand and a university degree in the other, with wallets containing thousand dollar bills," they still would have met tremendous resistance. Native-born Americans at the time identified with British culture and religion, believing that Irish Catholics were loyal to the pope and therefore suspect.

The thousands of Irish who poured into the Point, the Hill District, Lawrenceville, Homewood, and elsewhere in the decades following the Great Potato Famine were doubly despised because they were poor *and* Catholic. Still, they came. They lived in shantytowns and worked in the mills, factories, and mines, on the railroads, and in strangers' homes. The first immigrants often came without family, saving their money and sending it to relatives in Ireland to pay their passage to the United States, a practice that became known as chain migration.

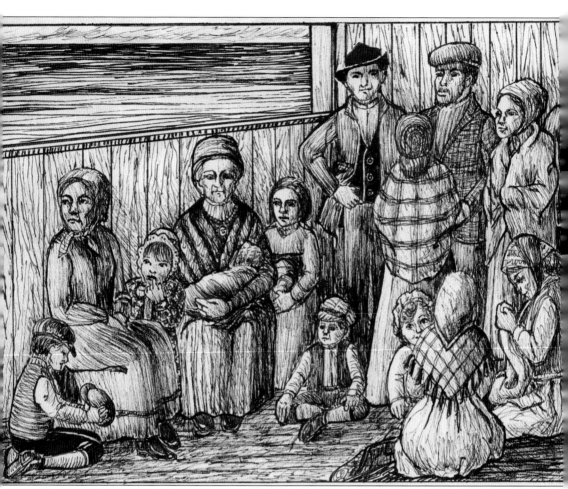

Nineteenth-century Irish immigrants who managed to pay for passage to America faced a difficult voyage. Crowded in steerage and expected to feed themselves, many immigrants became ill and died. Landing in the ports of Boston, Philadelphia, and, most often, New York, they were exploited by land agents who took them to rooming houses and fleeced them of what little money they had. (Drawing by Mary Anne Pischke.)

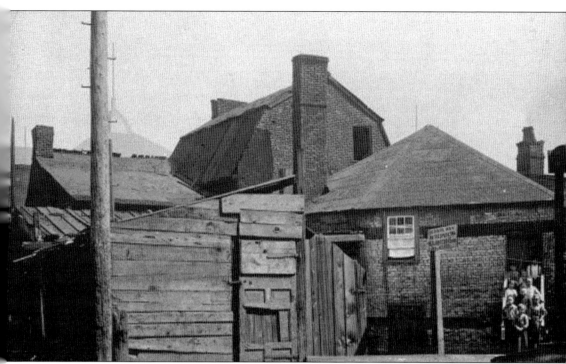

Today, the Fort Pitt Blockhouse stands alone in Point State Park, but in this 1893 photograph, it was being used as housing for Irish immigrants. The Point District was the center of the Irish community—so many immigrants crowded into its dilapidated buildings that the area was called Little Ireland. Nearby factories, a railroad, and other industries made the neighborhood a dangerous and unhealthy place to live. Sadly, the American ghetto was created by the thousands of Irish immigrants who gravitated to Pittsburgh and other cities, primarily in the Northeast, looking for work and the cheapest places to live. The blockhouse is all that remains of the original neighborhood and is the last surviving historic building from the original Fort Pitt. (Art Work of Pittsburgh, Part II.)

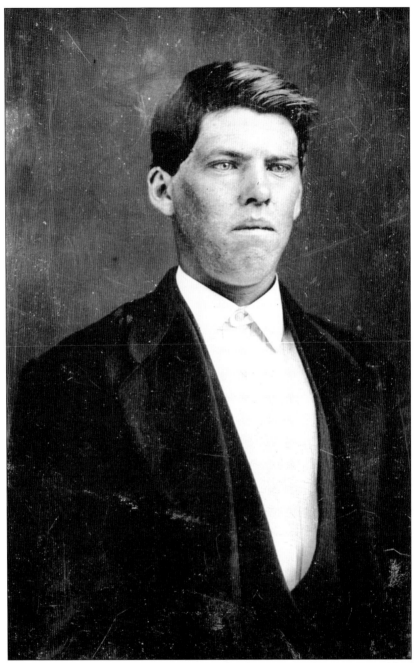

Unmarried men had few prospects in post-famine Ireland. Because only one son would inherit the family cabin and land, most young men faced a life of deep poverty in an already impoverished country. Between 1851 and 1921, approximately 4.5 million people left Ireland; 3.7 million of them headed for the United States. Almost half were men, like the figure in this photograph from the 1860s. Their jobs in the mills, mines, and railroads were so dangerous that scores of them died. Company owners took little or no precautions for their employees' safety. Historian S.J. Kleinberg wrote in *The Shadow of the Mills* that "immigrant laborers, at the bottom of the mill hierarchy . . . were the industrial equivalent of cannon fodder." (Courtesy of Hays family.)

Women left Ireland in greater numbers than men. In post-Famine Ireland, few poor Irish women had dowries to offer the families of prospective husbands and therefore could not hope to marry. With dismal prospects at home, women looked to the United States as the way to a better life. More single Irish women, like this one photographed around 1890, emigrated than unmarried women in any other European ethnic group. (Courtesy of Hays family.)

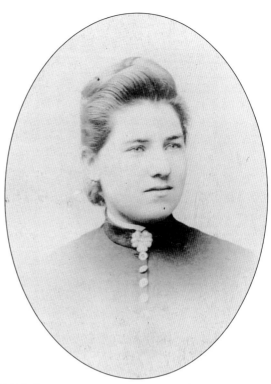

Fewer children, like this baby in the 1860s, left Ireland, because most émigrés were young unmarried women and men, who were overwhelmingly childless. Between 1880 and 1897, only 7.9 percent of Irish immigrants were under the age of 15. Children who did immigrate struggled to survive in the shantytowns and tenements where the Irish were forced to live. (Courtesy of Hays family.)

The struggles of Pittsburgh's Irish immigrants were detailed in two novels set in the late 1800s. Alexander Cordell's *Race of the Tiger* (1963), seen here, and Marcia Davenport's *Valley of Decision* (1942) follow, respectively, the O'Hara and Rafferty families as they try to adapt to the turbulent world of steel making and life in the Irish ghetto. Both books present highly romanticized but often accurate views of Pittsburgh. In *Race of the Tiger*, narrator Jess O'Hara describes the turbulence as he arrives on a flatboat along the Allegheny River: "We stared at a burning city, at roofs and chimneys aflame with fire-shot smoke that stained the river as with pools of blood. And the night was split with the beat of hammers. Hooves clattered on loading bays, bully voices screamed commands, and the moon was obliterated as we drifted to the jetty at Allegheny [City]." (Author's collection.)

Mary Cloherty O'Toole and John Patrick O'Toole emigrated from Ireland to Pennsylvania. In 1910, they lived on Cagwin Street in Beechview, and then moved to 1731 Fallowfield Avenue, also in Beechview. They raised six children and John worked for the phone company, probably as a laborer. The O'Tooles are seen at right in their 1903 wedding photograph. Below, they stand in front of their Fallowfield Avenue home in 1930. Irish Pittsburghers were loyal to their city and often became lifelong residents. (Both, courtesy of Lois O'Toole.)

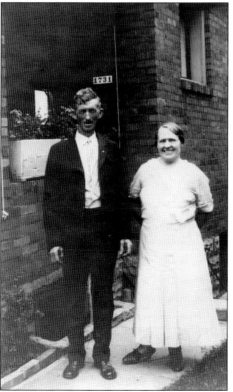

Michael McInerney, seen here with his wife, Margaret, on their wedding day, May 15, 1938, was born in County Clare in 1896. He immigrated to the United States in 1922 with only $60 and his abiding Catholic faith. Struggling to find a job in Pittsburgh, he saw signs on factories that warned, "Colored and Irish need not apply." He attended Westinghouse night school and retired as an engineer from Westinghouse after 39 years. (Courtesy of John E. McInerney.)

Margaret Lacey, seen here in her passport photograph on April 8, 1929, was born in County Galway and immigrated to Boston in 1929. Like her future husband, Michael McInerney, she brought only the clothes she wore and an extra pair of stockings. She worked as a low-paid domestic servant, but during the Great Depression, jobs were so hard to come by that at times she worked solely for room and board. (Courtesy of John E. McInerney.)

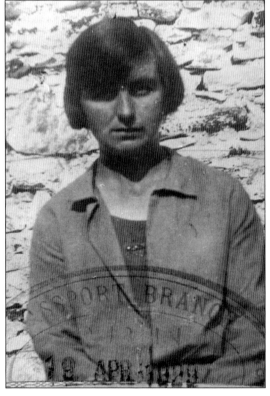

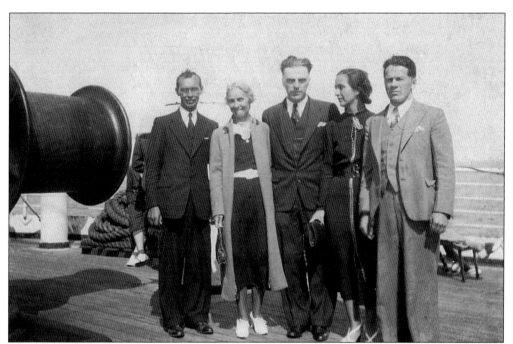

Discouraged by circumstances in the United States, Michael McInerney and Margaret Lacey both returned to Ireland and considered repatriating. Once there, they changed their minds and returned to America, meeting on the voyage back. They pose above on the ship in September 1937 with fellow passengers, from left to right, Rev. James Flaherty, Mary Lacey McLaughlin, Michael McInerney, Margaret Lacey, and an unidentified friend. (Courtesy of John E. McInerney.)

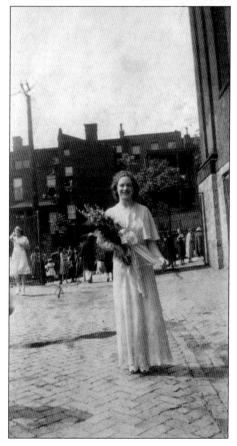

Although immigrants came from rural Ireland, they overwhelmingly chose to settle in cities, where jobs were plentiful, and in neighborhoods where other Irish families lived. Immigrants and their children settled in the North Side, Lawrenceville, Homewood, the Point, South Side, Hazelwood, and the Hill District, where this photograph was taken of Elizabeth "Dolly" Martin at a May 22, 1938, May Crowning at St. Brigid's Church. (Courtesy of McElligott family.)

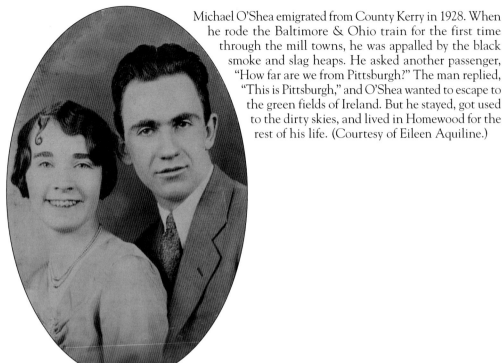

Michael O'Shea emigrated from County Kerry in 1928. When he rode the Baltimore & Ohio train for the first time through the mill towns, he was appalled by the black smoke and slag heaps. He asked another passenger, "How far are we from Pittsburgh?" The man replied, "This is Pittsburgh," and O'Shea wanted to escape to the green fields of Ireland. But he stayed, got used to the dirty skies, and lived in Homewood for the rest of his life. (Courtesy of Eileen Aquiline.)

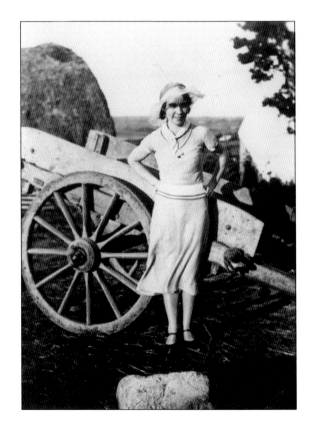

Nora Stack, seen here in a 1933 honeymoon photograph, grew up in the village of Duagh in County Kerry. She remembered the infamous Black and Tan soldiers, who suppressed local attempts at Irish independence, searching her family's home and threatening to arrest the man of the house. "They never beat us as they did some, but they scared us so. They were all armed and . . . would shoot men right alongside the road." She arrived in Pittsburgh in 1926, worked as a secretary, married Michael O'Shea, and raised five children with him in Homewood. (Courtesy of Eileen Aquiline.)

Helen O'Donnell Martin, seen above in 1957, emigrated from County Galway and worked as a domestic servant until she married in 1910. When she arrived in New York, someone gave her a banana. Helen had never seen one before and ate the fruit without peeling it. This naiveté was a source of embarrassment to Irish newcomers, who worked hard to avoid being called "greenhorns." (Courtesy of McElligott family.)

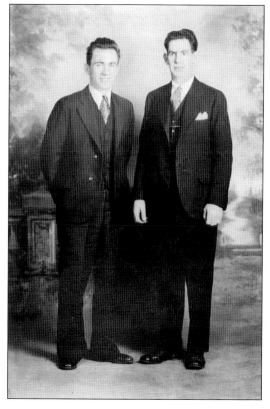

Not everyone stayed. Some immigrants went back to Ireland because they did not like life in the United States. Others left for more auspicious reasons, like John O'Shea, seen here standing to the right of his brother Michael in the late 1920s. John immigrated to America in the 1920s and settled in Lawrenceville. After he inherited the family farm in Dingle, he returned to Ireland and worked as a farmer for the rest of his life. (Courtesy of Eileen Aquiline.)

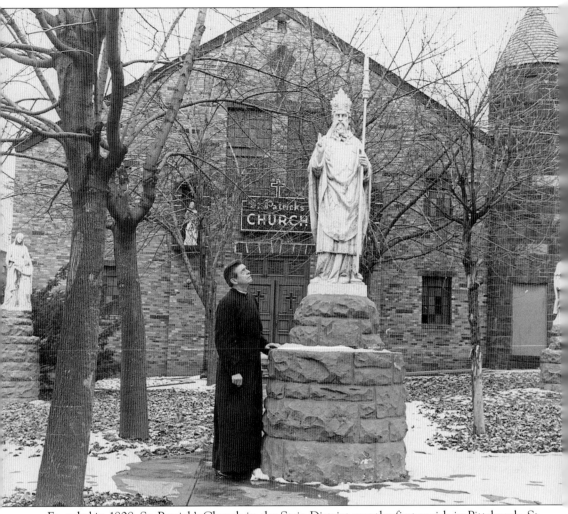

Founded in 1808, St. Patrick's Church in the Strip District was the first parish in Pittsburgh. St. Patrick's provided a priest on a permanent basis for the first time to Catholics in the region. After two churches were destroyed or torn down, the third incarnation of St. Patrick's was dedicated in 1865. It provided sustenance to Irish immigrants pouring into the city. During the Great Depression, St. Patrick's handed out over two million free meals and 500,000 baskets of food, clothing, and fuel to the poor. The church burned down in 1935 and the new church, dedicated in 1936, is seen here in the 1960s with an unidentified priest looking up at the statue of St. Patrick in the churchyard. (Courtesy of Dr. and Mrs. Mason, Father James Renshaw Cox Collection, Saint Patrick-Saint Stanislaus Kostka parish, Pittsburgh, PA.)

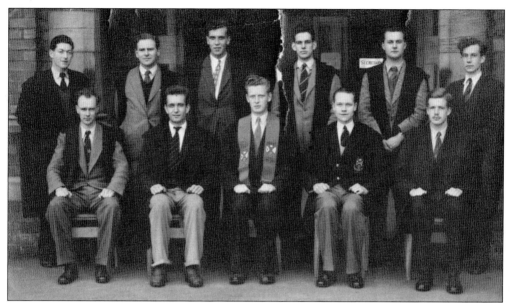

David F. Figgins emigrated from Belfast, Northern Ireland, to Toronto, Canada, and then to Pittsburgh in 1957. Here he is seated in the center of the first row with his classmates at Queens University of Belfast. He graduated in 1953 with a degree in civil engineering and was president of the Student Union Society in 1951. (Courtesy of David F. Figgins.)

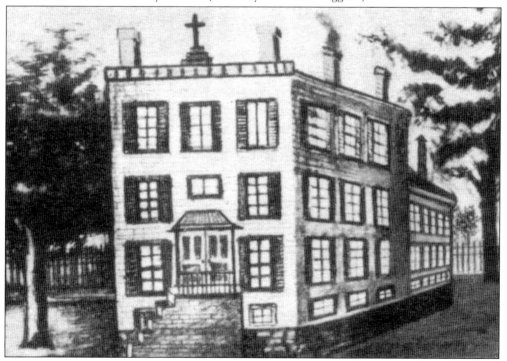

Speer House, shown in this 1844 drawing, was located in the 800 block of Penn Avenue downtown. It served as the first Sisters of Mercy convent in the United States. The Dublin-based order, brought to Pittsburgh by the diocese's first bishop, Michael O'Connor, provided critical support to struggling Irish immigrants. (Courtesy of Archives of the Sisters of Mercy in Pittsburgh, 2010.)

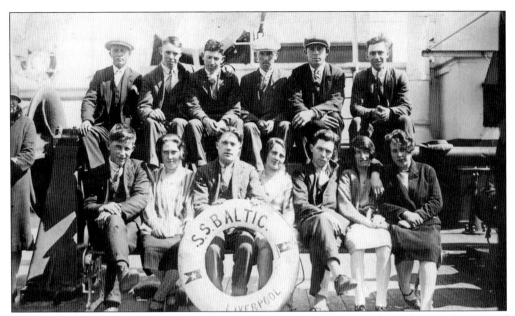

Immigrants to the United States, seen here in 1926 onboard the SS *Baltic*, left from the ports of Cobh and Belfast in Ireland or, like this group, from Liverpool in Great Britain. By the 1920s, sailing to America had become far more comfortable for the third-class passengers and they were more likely to arrive in Pittsburgh to waiting families. (Courtesy of Mary Frances Garrison.)

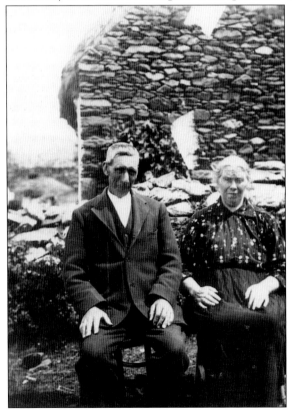

Michael and Johanna O'Shea sit in front of their stone cottage with a thatched roof in the late 1930s. Their children immigrated to Pittsburgh but they remained in Dingle. Many Irish immigrants suffered a terrible longing for their families, especially their parents, left behind. Thousands of letters and dollars crossed the ocean, offering comfort and reminding loved ones how much they were missed. (Courtesy of Eileen Aquiline.)

Two
WORK
"THEY EACH WHEELED THEIR BARROW"

She was a fish-monger, but sure 'twas no wonder
For so were her father and mother before
And they each wheeled their barrow
Through streets broad and narrow
Crying cockles and mussels, alive, alive-Oh!

From "Molly Malone"
James Yorkstown
Traditional Irish Folk Song

In the 1700s, the Irish came to eastern Pennsylvania as servants, trappers, and traders. They made their way west to the area that became Pittsburgh, creating new settlements along the rivers and valleys. These pioneers, Catholic and Protestant alike, set the precedent for the huge waves of 19th-century immigrants that followed, escaping repression and looking for work, which dominated the lives of the post-famine immigrants as well. The relentless need to pull in enough money to survive dogged their days and nights.

Men took jobs that put them in jeopardy: digging canals, mining coal, and, most often, slaving in and around the white-hot furnaces of Pittsburgh's great iron and steel mills. Their sisters and daughters also toiled in unsavory factories and mills, but most of them were employed as domestic servants. So abundant were Irish servant "girls" that the stereotypical maid, "Bridget," became a comical character in vaudeville, plays, and movies. But the work was hard and the women had to cope with the anti-Irish, anti-Catholic prejudices of the day, including the popular notion, in spite of all evidence to the contrary, that they were lazy and incompetent. The determination of these women to survive and pull their families into a better place laid the groundwork for the upward mobility that would propel the Irish into the middle class and beyond.

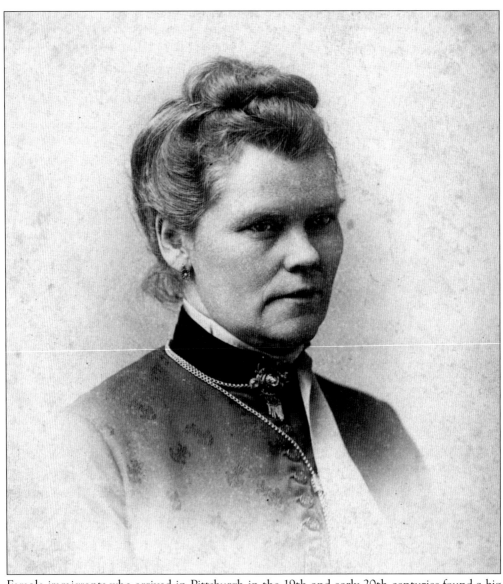

Female immigrants who arrived in Pittsburgh in the 19th and early 20th centuries found a big demand for household servants in the region. The woman in this 1890s photograph may have been a maid, a cook, or a housekeeper for a "respectable" family anywhere in Pittsburgh. More Irish women entered domestic service in the United States than any other occupation. The work was demanding and paid poorly; few native-born Americans would work as servants but young Irish women flocked to middle- and upper-class homes. Generally coming from lives of extreme poverty, these women lived in clean houses for the first time, had decent, though leftover, food, and were able to send money home to their kin in Ireland. Women in service became a model for Irish ambition, and eventually, Bridget the maid moved from serving in other people's homes to living in a decent home of her own. (Courtesy of Hays family.)

Once launched on a career in service, women like the one seen here had few other options. Young women usually remained in service until they married, when they were expected to quit their wage-earning jobs to maintain their own home and raise children. Women who did not marry often remained servants for the rest of their working lives. The benefit was that these women were able to save much of their earnings and achieve a level of independence. (Courtesy of Hays family.)

"No Irish Need Apply" was the infamous sign posted on factories and mills throughout the country in the late 1800s and early 1900s. A notorious symbol of anti-Irish prejudice, the sign guaranteed that immigrants, especially men, who were regarded as drunken louts, remained on the rock bottom of the economy, trapped in the lowest-paying and most dangerous jobs. (Drawing by Mary Anne Pischke.)

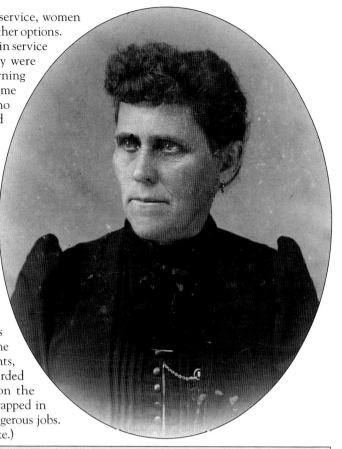

Domestic life was difficult for Irish-born women and their descendants. In this 1920s photograph, Lacey Green Schmalstieg tends to a child, probably her son, on the sidewalk near her home in Morningside. (Courtesy of Schmalstieg family.)

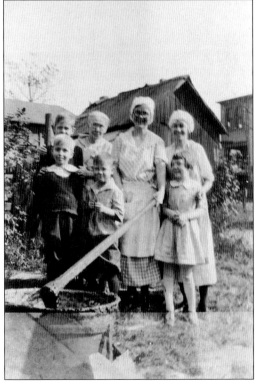

The Quigley family makes apple butter in their Verona backyard in 1924. The family includes, from left to right, (first row) Frederick Snyder, William Houston Quigley, and Jane Malvene Quigley; (second row) William Houston Quigley, Jane Malvene Jordan Quigley, Sarah Quigley, and Janet Quigley Snyder. (Courtesy of Quigley family.)

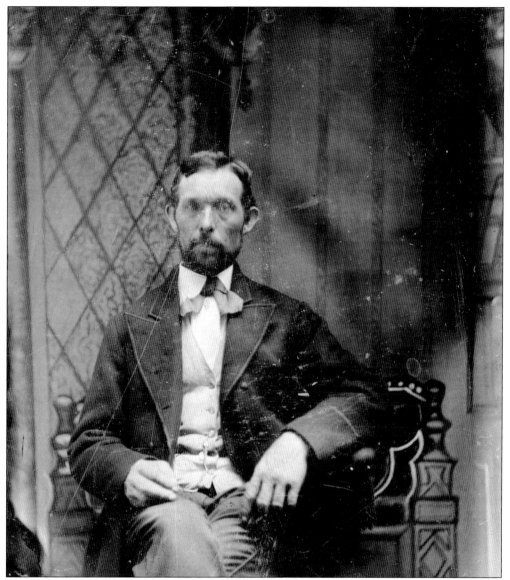

Although most male immigrants were unskilled laborers, the Irish occupied jobs at every level of the hierarchy. Irish-born lawyers and other educated men who arrived in Pittsburgh in the mid- to-late-1800s were able to practice their professions in the booming city. The man in this 1860s photograph may have been a manager or a businessman. Irishmen were also shopkeepers and clerks. Still, white-collar workers represented a tiny portion of employed Irishmen at the time. For most Irish workers, their status never changed—a blue-collar worker was a blue-collar worker for life. Due to poverty, prejudice, and other forces working against them, most immigrants did not realize the dream of upward mobility. However, their American-born children would find the opportunities denied to their parents. (Courtesy of Hays family.)

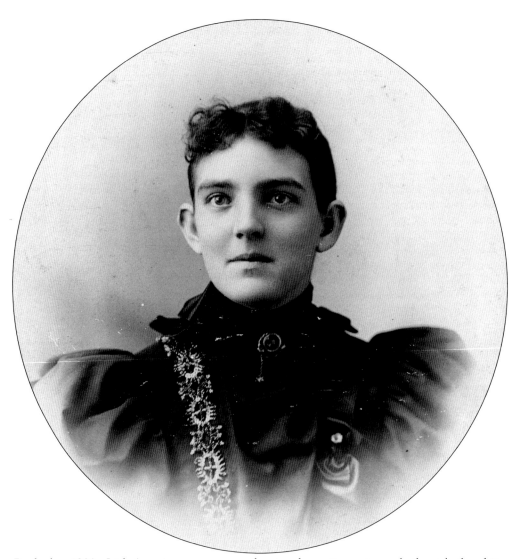

By the late 1800s, Irish American women were leaving domestic service and other jobs for white-collar positions that paid more and increased their status in the community. Nursing and teaching were rising professions for these women, but they required that their recruits remain single. Mollie Stowers, seen here on December 7, 1896, may have opted for a career over marriage and children. If she did, she probably would have lived with her family, sent money to relatives in Ireland, and taken care of her parents in their old age. Girls and young women were more likely than young men to use education to move ahead. At Pittsburgh Central High School, between 1855 and 1865, only 20 percent of the male students were Irish, but 37 percent of the female students were Irish. (Courtesy of Hays family.)

Frequent work-related deaths meant that many women became heads of the household and raised children alone. Widows had difficult lives, not only due to the loss of wages, but because few companies paid death benefits or offered any real help. Women tried to earn wages in their homes, so they would not have to leave their children, by taking in laundry or doing piecework. Still, many widows were forced to work in factories and mills to survive. (Courtesy of McElligott family.)

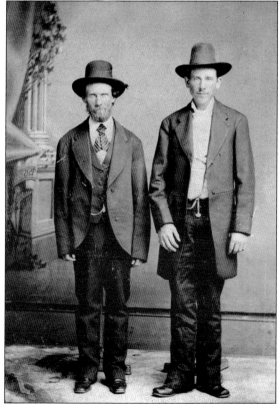

By the early 1900s, some Irish Americans were improving their economic prospects in the region. Between 1870 and 1900, the percentage of Irish men in Pittsburgh who worked in clerical or professional jobs rose from 8 to 15 percent. These two men, seen here in the 1870s, may have made the transition from laborers to clerks. (Courtesy of Hays family.)

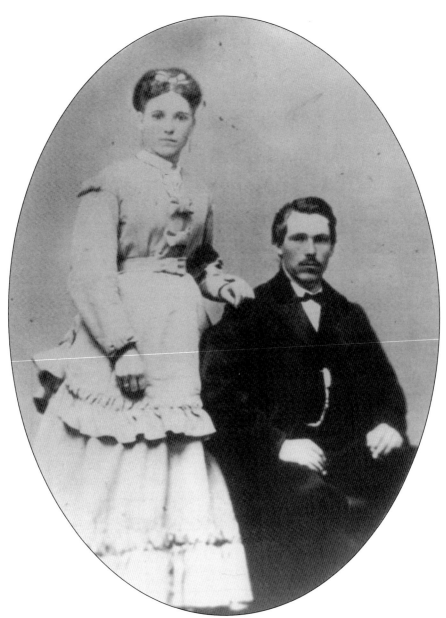

Daniel Nolan, shown here with his wife, Bridget Kane, at their wedding on May 25, 1870, emigrated from County Mayo to the United States in 1853 at the age of four. Nolan was one of thousands of Irish immigrants who worked on the Pittsburgh & Lake Erie Railroad. Unlike most immigrants, he managed to advance and was eventually promoted to superintendent of construction crews. After 1890, he established his own construction company and, by 1900, was the head of construction and maintenance work on the Low-Grade Division of the Allegheny Valley Railroad. In this job, Nolan helped to reroute a portion of the main line damaged by the Johnstown Flood of 1889. He became a prosperous and respected citizen, at one point even owning a private railroad car. Unfortunately, Nolan made bad investments and died in 1920 with most of his fortune lost. (Courtesy of the Nolan-Haller family.)

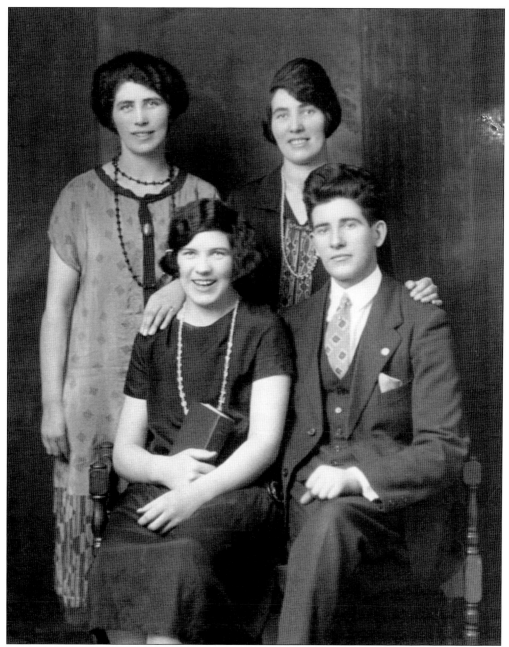

New job opportunities awaited immigrants in the 1920s, but continuing anti-Irish prejudice and a fluctuating economy kept many of them in traditional low-paying jobs. The Donohue siblings emigrated in 1925 from County Roscommon. Seen here in the year they arrived in the United States are, from left to right, (sitting) Josephine and Thomas Donohue; (standing) Beatrice and Martha Donohue. Beatrice continued the Irish practice of working as a housekeeper, in her case for a wealthy family on Fifth Avenue in Oakland. Josephine started her career as a seamstress at Joseph Horne's Dry Goods downtown, and, like most Irish American women, quit her job when she got married in 1934. Martha married Thomas McKenna after her arrival in the city, and Thomas worked for the Pennsylvania Railroad for 38 years. (Courtesy of Lois O'Toole.)

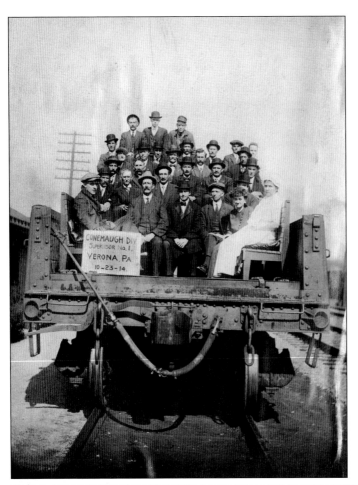

The staff of the Conemaugh Division of the Pennsylvania Railroad poses on a railroad car at the Verona Yards on October 23, 1914. The Pennsylvania Railroad was chartered in 1846, opening a new means of transportation and a new source of jobs for the Irish in Pittsburgh and throughout Pennsylvania. (Courtesy of Hays family.)

One benefit of working on the Pennsylvania Railroad was that family members rode for free. The pass below was assigned to Frederick T. Hays, "son of B.K. Hays, Wreck Master," for his May 7, 1936, trip from Warren, Pennsylvania, to Pittsburgh. (Courtesy of Hays family.)

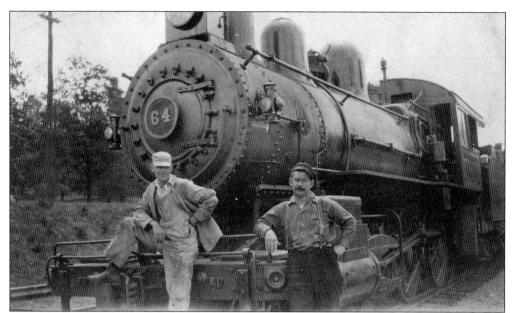

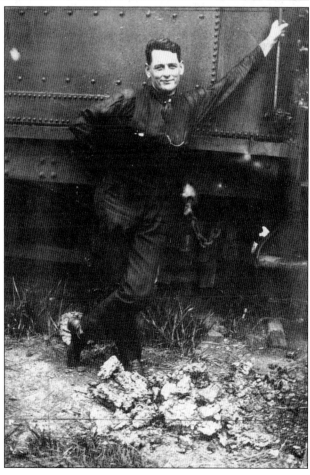

Brown Hays, seen above in the 1930s leaning against an engine, probably in the Verona Yards, worked as a flagman and baggage master for the Pennsylvania Railroad. Hays's brother Robert (right) was an engineer for the same railroad. Railroading was hard, dangerous work; conditions were hazardous and men were frequently injured or killed. Men often fell under the cars or between them and feet and fingers got severed. Bad weather, especially snow and ice, accelerated the number of accidents. By the 1930s, conditions had improved, but automobiles, airplanes, and the Great Depression contributed to a decline in passengers and mileage. (Both, courtesy of Hays family.)

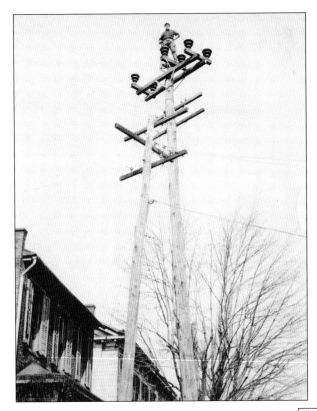

Irish Pittsburghers, especially men, often paid a high price for their work. Frederick Hays, who lived in Kittanning and is seen here atop a pole in the 1930s, was a lineman for the Pennsylvania Railroad. He died when a pole he was working on fell on top of him. (Courtesy of Hays family.)

After crushing the 1892 Homestead Strike, the Carnegie Steel Company, followed by other steelmakers, required that its laborers work 12-hour shifts, six or seven days a week. This draconian system depended on women assuming all household chores and reinforced the separate functions of paid work and unpaid domestic labor. In this 1920s photograph, from left to right, Susan Hays, Susan Hanlon, and an unidentified woman take a break in a backyard, most likely in Verona. (Courtesy of Hays family.)

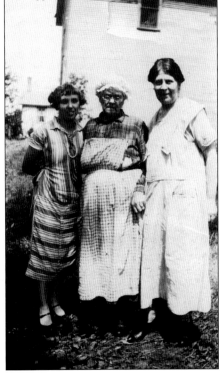

Irish Pittsburghers were also fervent actors in the labor movement. Father (later Monsignor) Charles Owen Rice (1908–2005) was known as the labor priest and fought for union workers' rights and against Communism. In an era when few priests were active in political movements, Rice, who served in the Diocese of Pittsburgh for seven decades, was seen as a rabble-rouser who led the way for other clerics to involve themselves in controversial causes. (Courtesy of Charles McCollester.)

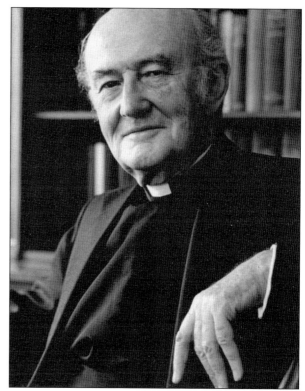

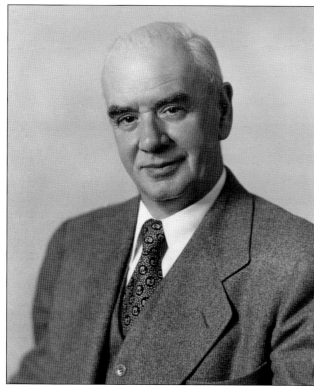

One of the most effective activists for the workingman was labor leader Philip Murray (1886–1952), seen here in the early 1950s, shortly before he died. As a coal miner in southwestern Pennsylvania, Murray experienced firsthand the cruelty of mine owners when his family was evicted from their company-owned home for inspiring a strike. Murray devoted his life to the unions and was a giant in the labor movement, becoming the first president of both the Steel Workers Organizing Committee and United Steelworkers of America, as well as president of the Congress of Industrial Organizations. (Courtesy of Charles McCollester.)

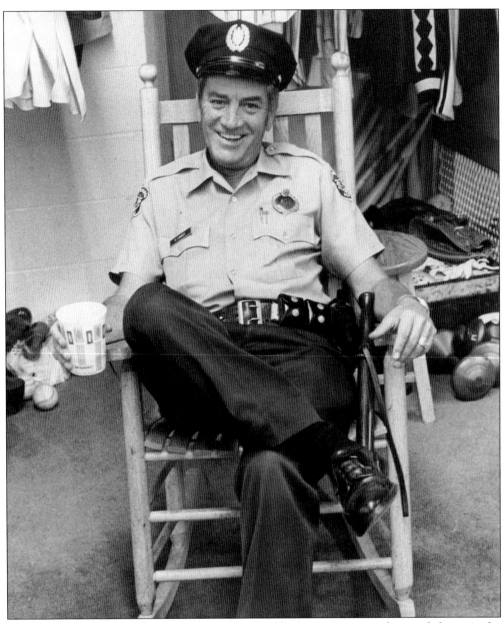

Just as "Bridget the maid" became a stereotype, "Paddy the cop" was another stock figure in the 1800s and early 1900s because so many Irish Americans became police officers. Robert "Bobby" Conroy was a member of the Pittsburgh Police Department from 1951 to 1988. His mother, Agnes, emigrated from Ireland in the early 1900s and became a domestic employee for the James Hillman family before she married. Bobby's father worked on the railroad and died when Bobby was only five years old. A lifelong resident of South Oakland, he grew up attending sporting events at nearby Forbes Field and Duquesne Gardens. As a police officer, he provided security during Pittsburgh Pirates and Steelers games, and one of his duties was to guard the Schenley Hotel, where the Yankee players stayed in the 1960 World Series. "You couldn't live in Oakland and not be a sports fan," Conroy said. He is seen here in Pirates general manager Danny Murtaugh's chair in the clubhouse in 1978. (Courtesy of Mary Lou Conroy.)

During the famous 1936 St. Patrick's Day flood, Irish police officers turned out in force to rescue victims of the rising waters, many of whom were also Irish. In this photograph from March 17 or 18, 1936, rescuers in a rowboat help a stranded person out of an upper-story window in a downtown building while other stranded people watch from nearby windows. (Courtesy of Quigley family.)

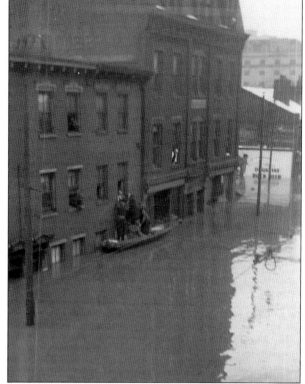

Irishness was a point of pride for police officers and they enjoyed showing their colors. Below, patrolmen from the Pittsburgh Police Department march in the 1965 St. Patrick's Day parade in downtown Pittsburgh. (Courtesy of Timothy Daniel O'Brien.)

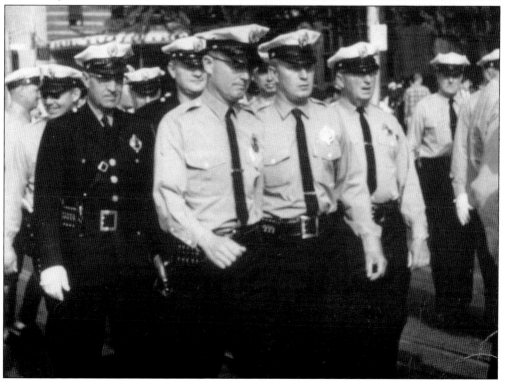

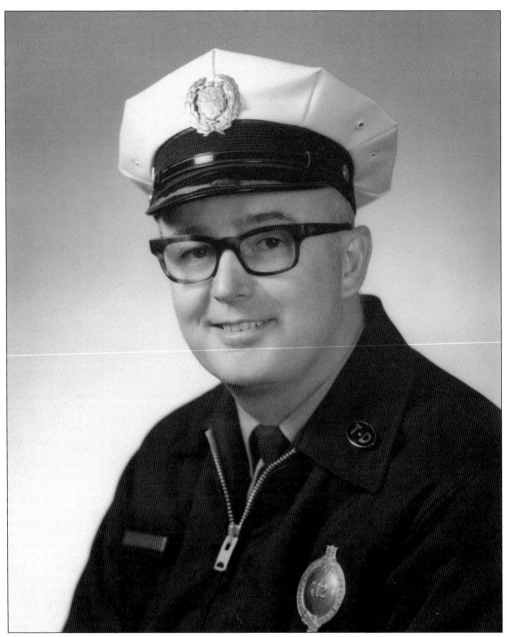

Timothy O'Brien, seen in his uniform in 1971, joined the Pittsburgh Police Department on January 8, 1951. He was a patrolman in the traffic division, first walking a beat in Manchester and later downtown. O'Brien used his job as leverage for a better life. In May 1954, his family moved from a rented apartment in Arlington Heights to a new house they purchased on Rosetta Street in Garfield. In 1970, they moved to Brookline. (Courtesy of Timothy Daniel O'Brien.)

Teaching was one of the first professions embraced by Irish Pittsburghers, including religious women. The Sisters of Charity provided teachers to educate thousands of Catholic children in parishes across the diocese. Many of those students became teachers themselves. The local congregation of Sisters of Charity was, and still is, headquartered in Greensburg. This 1950s prayer card honors the order's founder, Blessed (later Saint) Elizabeth Ann Seton. (Author's collection.)

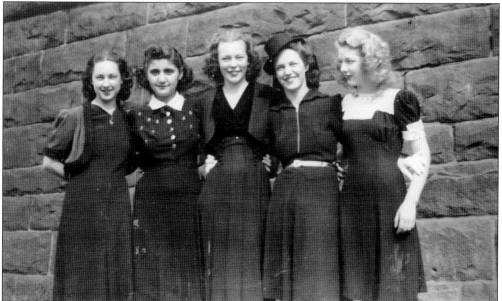

World War II created new opportunities for young women in Pittsburgh. Margaret Martin, seen at the far left with her friends and her sister Elizabeth (second from right) in the early 1940s, grew up in the Hill District. Margaret's mother worked as a domestic servant and her father was a plumber, but unlike her immigrant parents, Margaret took an office job downtown as a stenographer. (Courtesy of McElligott family.)

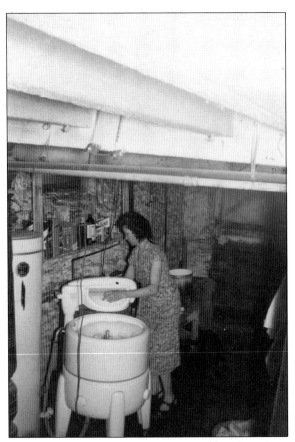

By the mid-1900s, Irish Pittsburghers had access to modern appliances, which made their housework less grueling. Still, large families created a heavy workload for many women and doing the laundry every day of the week except Sunday was not unusual. In this 1954 photograph, Blanche Altman puts clothing through a wringer washer in the basement of her daughter's Brookline home. (Courtesy of Anne Feeney.)

After the Great Depression, Irish Pittsburghers commanded better jobs and salaries. More men became firefighters, owned retail businesses, and entered municipal government. John McElligott of the Hill District began his career on the railroad. By 1938, McElligott (first row, third from left) was a supervisor in the Shipping, Gasoline Test and Beer Meter Assembly area at Rockwell Manufacturing Company in Homewood. (Courtesy of McElligott family.)

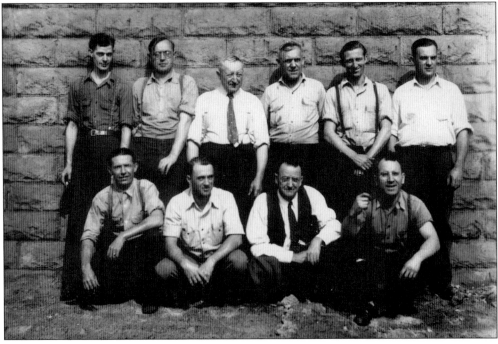

Mayor David L. Lawrence (far left) is seen here with business leaders on the cover of *Rockwell News* in October 1953. With him are, from left to right, Richard Zimmer, N.W. Rowand, and Paul D. Tharp. The mayor forged close ties with corporate leaders during his terms in office, relying on their support to bring in new industry and implement smoke and flood controls. (Courtesy of McElligott family.)

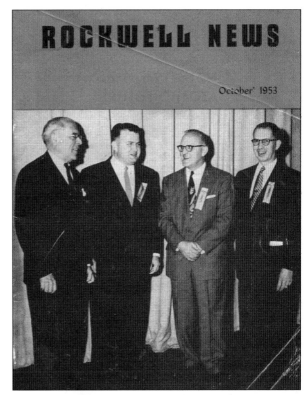

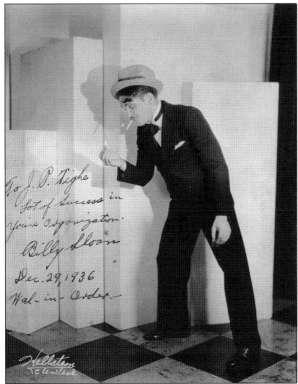

A common means of upward mobility for the Irish was bar ownership. John Pre Tighe owned a club in the 1930s on Fourth Avenue downtown. This publicity photograph for one of his entertainers, Billy Sloan, hung in the bar. The message reads, "To J.P. Tighe Lots of success in your organization. Billy Sloan, Dec, 29, 1936 – Wal-in-Order –". (Courtesy of Patricia Moorhead.)

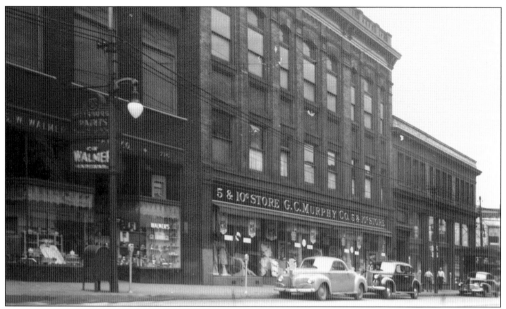

This G.C. Murphy Co. 5 & 10¢ Store was on Penn Avenue in Wilkinsburg in 1940. The company was founded in McKeesport in 1906 by George Clinton Murphy and grew to more than 500 stores in 26 states before it was sold to Ames Department Stores in 1985. Murphy's five-and-dimes dotted business districts all over the Pittsburgh region. (Courtesy of Wilkinsburg Historical Society.)

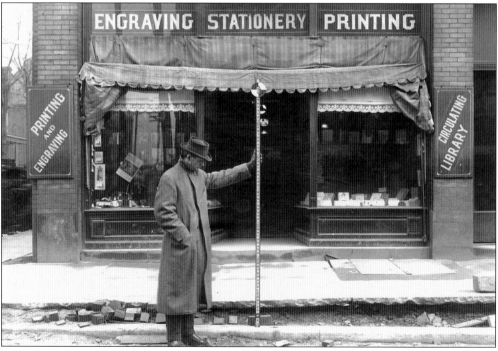

E.M. McClain owned this stationery store on Wood Street in Wilkinsburg. He later sold it to Harrison J. Hays, who managed the business in this location for decades. In this 1914 photograph, a man holds a surveyor's rod as part of a plan to lower Wood Street. (Courtesy of Wilkinsburg Historical Society.)

Three
FAMILY
"Her Good Ould Irish Way"

Over in Killarney
Many years ago,
Me mither sang a song to me
in tones so sweet and low.
Just a simple little ditty,
In her good ould Irish way.

From "An Irish Lullaby"
Traditional Irish Song

Family life was a challenge for new Pittsburghers in the late 1800s. Immigrants lived in the poorest neighborhoods and struggled with poverty, crime, and disease. As their lot improved, generally with the second or third generation of American-born children, they acquired nicer homes, modern comforts, and the longed-for respectability that their parents and grandparents had been denied.

Even as they assimilated, the immigrants who escaped Ireland did not lose their close connections with the homeland. As Jay P. Dolan wrote in *The Irish Americans*, "Families, an ocean apart, remained united in affection through the simple bond of letters sent to loved ones." The newcomers also helped their kin immigrate to this country in such great numbers that the Irish Diaspora population of the United States is roughly six times the modern population of Ireland. Chain migration ended for the most part when Irish immigration slowed to a trickle during the Great Depression.

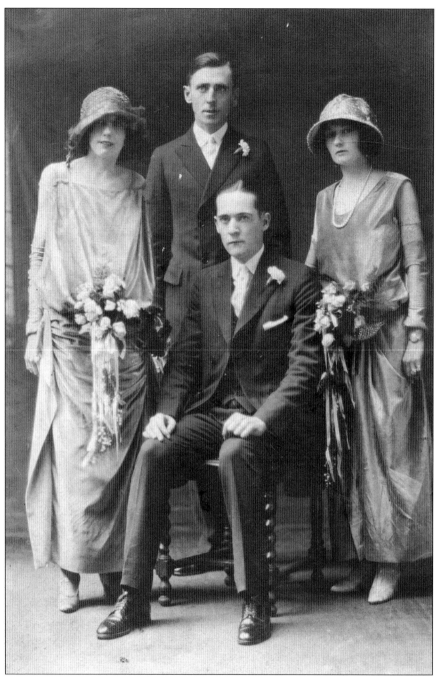

The wedding party poses at the 1922 marriage of Mary Sweeney (left) and Martin F. O'Connor (seated). Their attendants are the groom's brother, Matthew O'Connor, and the bride's sister, Katie Sweeney. The O'Connors lived in Garfield and raised two children there. For Irish American families, the 1920s were marked by growing prosperity and a surge of pride in their Catholicism, buoyed by New York governor Al Smith's campaign for the presidency in 1928. Smith's loss to Herbert Hoover, generally ascribed to his Catholic religion, was a bitter blow to his fellow Irish Americans. (Courtesy of O'Connor family.)

In the 19th century, middle-class Irish families led lives that were strikingly different from their immigrant neighbors. They were healthier and wealthier, living in relative cleanliness removed from the grime of the steel mills. By the 1880s, the couple in this photograph could have moved to a suburb like Shadyside and lived in a new house with plumbing on a paved street with good sewage, a critical amenity for avoiding infectious diseases. (Courtesy of Hays family.)

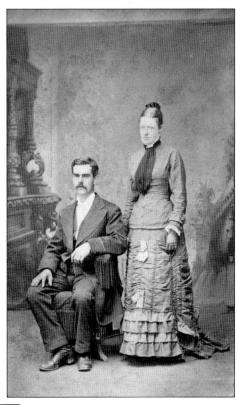

Anne Marie Kearney McGough (1885–1977), seen here around 1910, was born in the Hill District to Irish American parents. Her grandparents immigrated to Pittsburgh during the famine years, between 1845 and 1850. McGough never discussed the sadder aspects of the family's history with her grandchildren because, she told them, "Skeletons should sometimes stay in the closet." (Courtesy of Quigley family.)

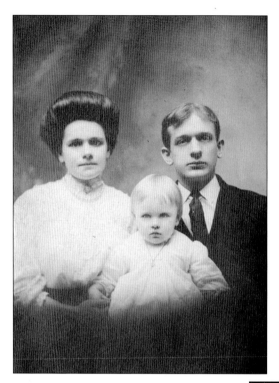

A young couple poses with their toddler around 1900. The mother, once married, would not have worked outside the home. Domesticity was demanding and women's lives were completely absorbed by home and hearth. The father may have been employed in a white-collar job and would have put long hours into it. The division of labor spawned by the Industrial Revolution forced families to function in separate spheres. (Courtesy of McElligott family.)

In the late 1800s, most Irish Pittsburghers married within their ethnic group. The two men in this 1860s tintype would have married Irish women of their own class and religion. By 1900, that tradition was changing, especially for men. Due to the shortage of eligible female partners, 22 percent of Irish Pittsburgh men married non-Irish women, usually native-born Americans. Only 14 percent of Irish women married non-Irish men. (Courtesy of Hays family.)

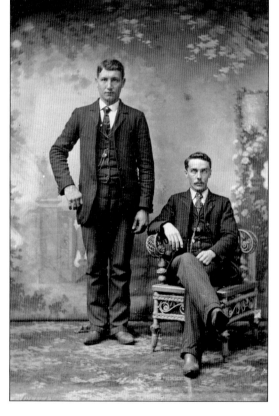

In the early 1900s, more Pittsburghers had become "lace-curtain" Irish, named for the drapes that hung in the windows of prosperous Irish Americans' homes. Around 1910, this family posed in front of a backdrop of Niagara Falls. The polished dress and judicious poses of mother, father, and child suggest the level of respectability and acceptance by the Protestant mainstream that some Irish Americans were able to achieve by the 1910s and 1920s. (Courtesy of McElligott family.)

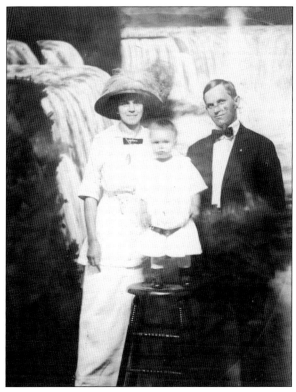

James Sharon Quigley and Sarah Ann Farnen are seen here at their wedding on June 4, 1913, at Manchester Presbyterian Church on the North Side. They settled in that area and raised two children. Quigley was a draftsman for Hunter Steel Company and an amateur photographer. (Courtesy of Quigley family.)

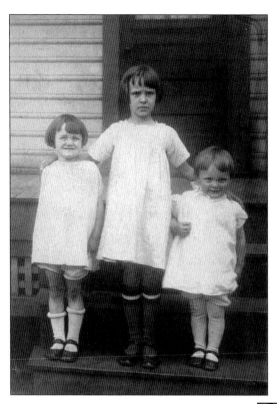

In an economy driven by a relentless demand for labor, families had to enlist every member in order to survive. The children of unskilled laborers, especially, were often pushed into the workforce at an early age. These three girls, seen around 1900, may have worked in a factory or done piecework at home. As their lot improved, families tried to keep their children from such hardships. (Courtesy of McElligott family.)

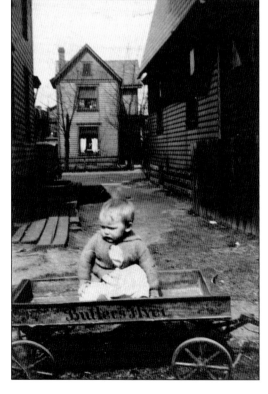

Children lived in danger in the poor city neighborhoods where Irish immigrants lived. Crowding, ramshackle housing, and lack of sanitation led to high mortality rates from infectious diseases. This Pittsburgh child, seen around 1900, had a better chance of surviving if she came from a family of skilled rather than unskilled laborers because the higher wage allowed for a higher standard of living. (Courtesy of McElligott family.)

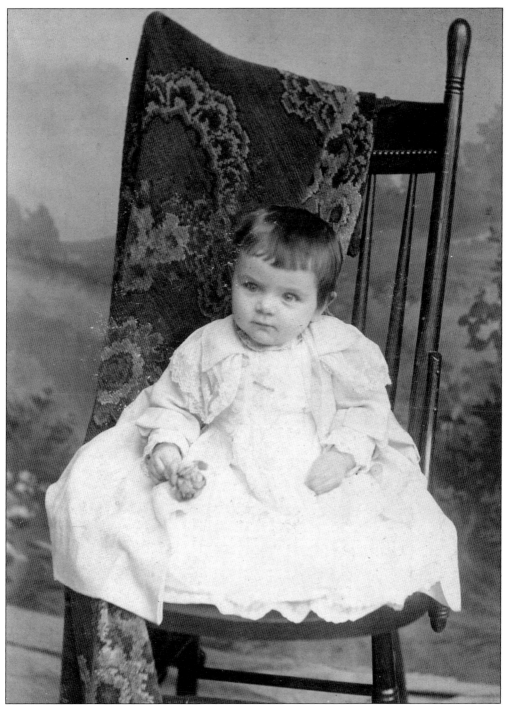

A child born to middle-class parents, like this baby pictured in 1894, had far higher survival rates than the children of working-class parents. Major causes of death for infants in Pittsburgh between 1875 and 1900 included neonatal (often premature birth), respiratory disorders, diarrhea, nutritional deficiencies, and infectious diseases like smallpox, measles, and diphtheria. Many deaths could be attributed to poverty, like hunger and poor sanitation. (Courtesy of Hays family.)

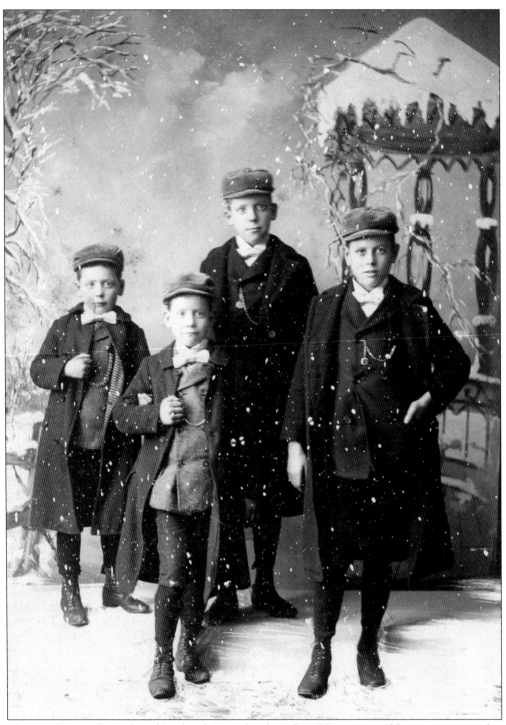

Thomas, Brown, Samuel, and Frederick Hays, brothers from Verona, pose like grown-ups in this studio photograph from around 1910. Note the artificial snowfall and the façade of a snow-covered house in the background. The Hays brothers grew up to work on the Pennsylvania Railroad, which had a large yard in Verona. (Courtesy of Hays family.)

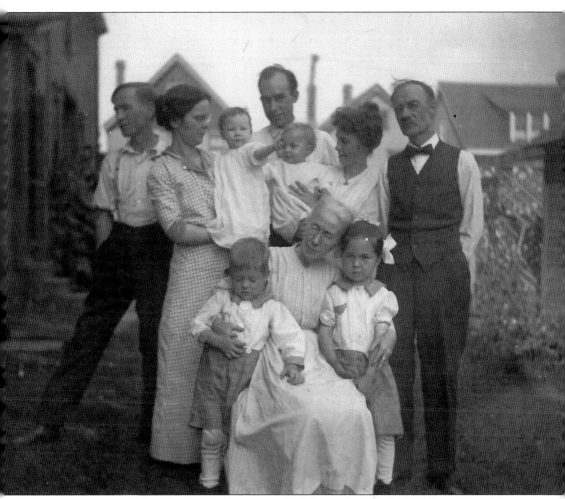

Three generations of the Quigley family pose in the Verona backyard of William H. and Jane Malvene Jordan Quigley in 1915. Jane, the grandmother, is seated in the front of the photograph with her arms around her two grandchildren, William and Malvene. The two women standing behind her are, from left, her daughter-in-law, Sarah Farnen Quigley, and her daughter, Jane Quigley Snyder. They are each holding their own children, Jane and Frederick. The men are, from left to right, John Quigley, a pipe fitter; Frederick Snyder, a steel mill foreman; and the grandfather, William H. Quigley, a machinist who was likely retired by this time. The one missing member is James S. Quigley, an amateur photographer, who shot this picture. The Quigley family had lived in Pennsylvania since the Revolutionary War era. Each succeeding generation moved westward across the state: from Hopewell in Berks County, to York in York County, to Pine Creek in Armstrong County, to Kittanning, Verona, and Pittsburgh. Quigley ancestors include a soldier in the First Continental Army, a farmer, and the owner of a sawmill. (Courtesy of the Quigley family.)

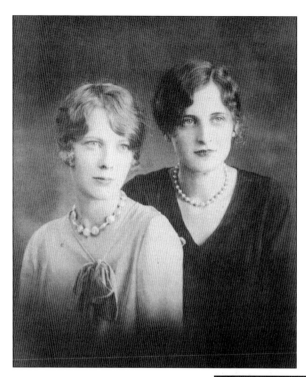

Beautiful sisters Leone "Nonie" and Kathryn "Kay" Nolan, seen here in the 1920s, were raised in Sheraden. Nonie married Lee Haller and raised a son, Daniel, in Upper St. Clair. Kay married Haller's brother, John, and moved to a farm in Venetia, Pennsylvania, where she lived for 44 years before the couple retired to Scott Township in 1984. In spite of the distance between them, the two sisters remained close their entire lives. (Courtesy of Nolan-Haller family.)

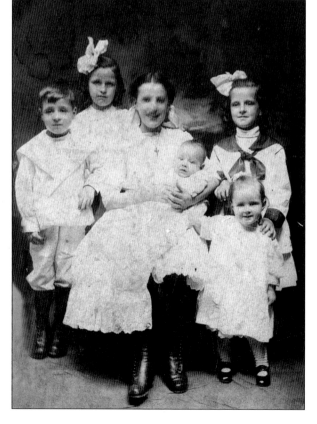

The Downey children, from Hazelwood, posed for this portrait around 1910. From left to right, they are William, Agnes, Mary (seated, holding Katherine), Ellen, and James. This second generation would make sweeping changes in Irish America. These children would get a better education and make more money than their immigrant parents, pulling the Irish into the middle class. (Courtesy of Brennan family.)

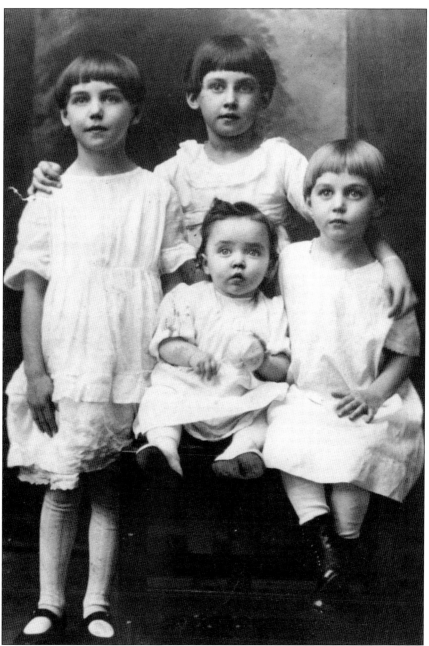

Margaret Martin drapes her arms protectively over the shoulders of her sisters, Elizabeth (left) and Rita (right) in this 1928 photograph. Their sister Helen sits on a chair in front of Margaret. The Martins were a working class family who struggled to make ends meet. During the Great Depression, their father, Dudley Martin, lost his job as a plumber and never recovered from the loss. He died of pneumonia in 1938 at the age of 52, leaving seven children for his widow, Helen, to raise alone. Like many women during the Depression, Helen struggled to care for her family without a husband to support her. One long-practiced economy is shown here: she cut her daughters' hair by putting a bowl on their heads and trimming along the edges, hence the bowl cut that three of the girls sport in this photograph. (Courtesy of McElligott family.)

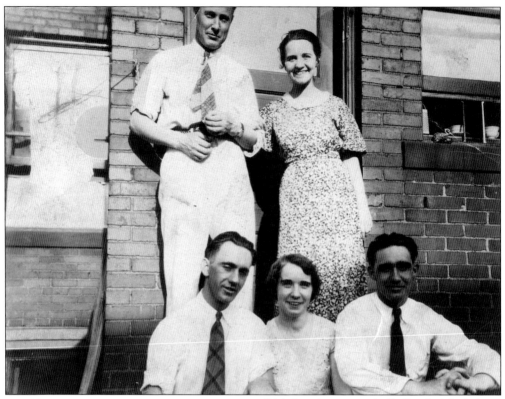

Irish immigrants typically lived with their families when they came to Pittsburgh. In this photograph from around 1935, the O'Sheas pose on the steps of their house in Homewood. They are, from left to right, (sitting) Michael O'Shea, Nora O'Shea and Cornelius Stack; (standing) an unidentified man and Mary Stack. (Courtesy of Eileen Aquiline.)

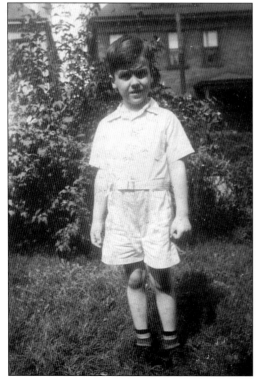

John McInerney, shown here in the yard of his Homewood house in the 1940s, remembered his parents talking wistfully about "going back to Ireland." John echoed the phrase during his childhood and beyond. When he finally took a trip in 1972 to his father's village in Ireland, his aunt Bridie, whom he had never met, greeted him by saying, "Welcome home." (Courtesy of John E. McInerney.)

Tuberculosis was a deadly threat to Pittsburghers in the 19th and 20th centuries. Shirley Griffin O'Brien, seen here as a teenager in 1943, was diagnosed with the disease in 1953 when she was raising three children in Arlington Heights. She was admitted to Leech Farm Tuberculosis Sanitarium in East Liberty. Expecting to stay for one month, O'Brien stayed for 13 months and was cured by bed rest and innovative drugs. (Courtesy of Timothy Daniel O'Brien.)

Rita Martin, from the Hill District, married Edward Schramm and moved to Florida. These two actions revealed changing customs for Irish Pittsburghers. She married a non-Irish person and moved out of the region. Martin is seen here with her three-year-old daughter, Joyce, in February 1944. (Courtesy of McElligott family.)

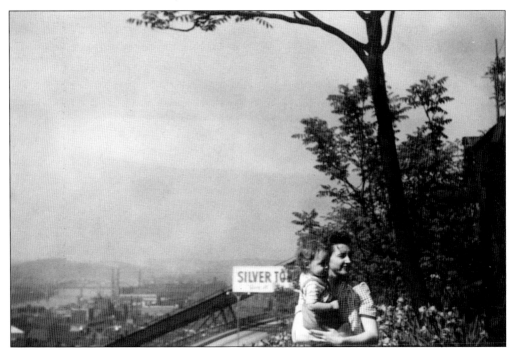

Margaret McElligott holds her son Owen in the backyard of her in-laws' home on Crescent Street in the Hill District in 1952. In spite of recently enacted anti-smoke laws, the skies above are gray and smoke rises from the steel mills lining the river below. (Courtesy of McElligott family.)

The Irish visited their American kin in large numbers. Here, the O'Sheas from County Kerry visit the O'Shea family in Homewood in August 1955. (Courtesy of Eileen Aquiline.)

Irish Catholics were renowned for their large families. One mother of eight said, "We went to church and Father said, 'Be fruitful and multiply.' So we did." Here, five of the six McInerney children pose with their parents in their Idlewild Street home in Homewood in 1952 or 1953. From left to right are (seated) Margaret, Michael Francis, James, Joseph, and Michael McInerney; (standing) Kathleen and John McInerney. (Courtesy of John E. McInerney.)

The eight Quigley children pose in this Christmas photograph taken in December 1956 at their home on the North Side. They are, from left to right, (sitting) Sarah, Thomas, John, and Mary Ann Quigley; (standing) Elizabeth, Kathleen, James, and William Quigley. (Courtesy of Quigley family.)

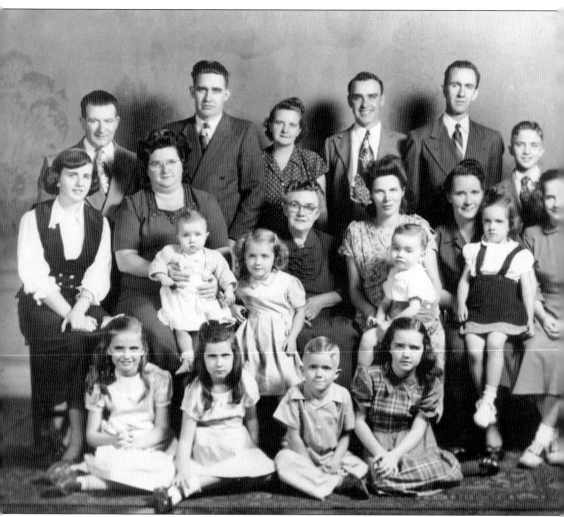

The Clark-O'Shea-Stack family, from Swissvale and Homewood, pose for a formal photograph in 1949 to commemorate a visit from matriarch Sarah Ford Stack, who came from Duagh in County Kerry. Wearing glasses and a dark dress, she sits in the center of the photograph, surrounded by three generations of children, grandchildren, and in-laws. The family includes, from left to right, (first row) Sally O'Shea, Mary Frances Clark, Patrick Stack, and Connie Stack; (second row) Eileen O'Shea, Mary Audley Stack (with Margaret Stack on her lap), Dolores Stack, Sarah Ford Stack, Eileen Stack (with John Stack on her lap) Nora Stack O'Shea (with Joan O'Shea on her lap) and Brenda O'Shea; (third row) Francis Clark, Cornelius Stack, Mary Stack Clark, John Stack, Michael O'Shea, and Jack O'Shea. (Courtesy of M.F. Garrison.)

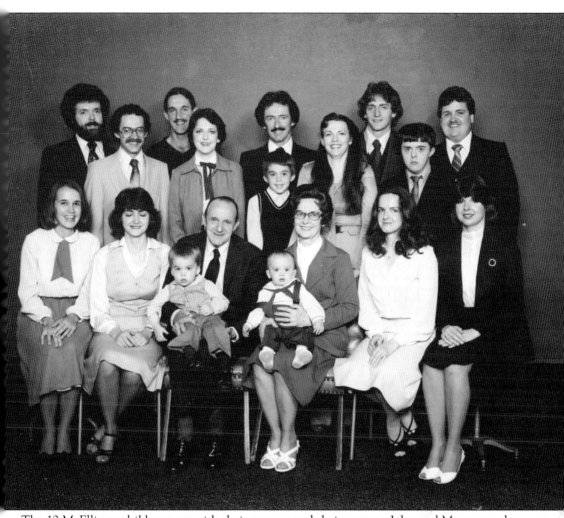

The 10 McElligott children pose with their spouses and their parents, John and Margaret, who hold two of their three grandchildren, in Wilkinsburg in 1981. Families grew and prospered, often leaving behind old neighborhoods and churches. In the 1960s and beyond, more Irish families lived in the suburbs. Their children went to college and never put a foot in the mills. (Courtesy of McElligott family.)

A Record of My Trip

On the

S.S. MANHATTAN
The Largest Steamer Ever Built in America

FROM

HAMBURG	AUGUST 24th, 1938
HAVRE	AUGUST 25th, 1938
SOUTHAMPTON	...	AUGUST 26th, 1938
COBH	AUGUST 27th, 1938

TO

NEW YORK

And a List of Fellow Passengers

In spite of their family's trepidation that they would never see their immigrant kin again, Pittsburghers did make the trip home to Ireland. Mary Stack, from Wilkinsburg, returned to Duagh in County Kerry to reunite with her family in 1938. At left is "A Record of My Trip," a souvenir handed out to the passengers onboard the SS *Manhattan*. Below, Stack poses with her fellow passengers on the right side of the deck behind a lifebuoy with the ship's name written on it. (Both, courtesy of M.F. Garrison.)

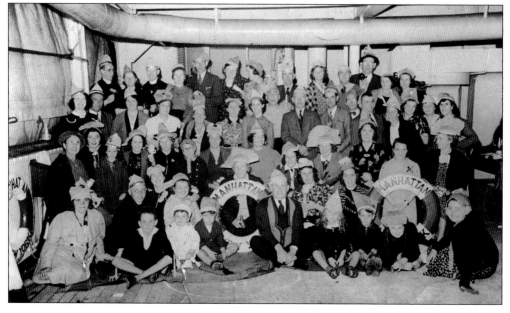

Four
RELIGION
"THE BINDING FORCE"

Religion has been the binding force in Ireland.
It's what has kept the Irish from despair.

Michael O'Shea

Michael O'Shea's simple statement to the *Pittsburgh Catholic* newsweekly in March 1977 is a tribute to the institution that offered the Irish solace during their early years of hardship. Immigrants carried this profound feeling for the Catholic Church with them to the United States, a country that was harsh and unwelcoming to the new arrivals and to their religion. Struggling to survive, the Irish received support from Catholic parishes, which provided basic necessities and spiritual homes. St. Patrick's Church in the Strip District fed thousands of immigrants during the Great Depression. The Dublin-based Sisters of Mercy founded its first American order in Pittsburgh at the invitation of the diocese's first bishop, Michael O'Connor, and provided medical care, housing, and job training for the destitute immigrants.

The church became the Irish refugees' community center: they worshipped there and built their social lives around parish events and groups like Knights of Equity, Christian Mothers, and the Sacred Heart Society. They sent their children to Catholic parish schools, including Holy Rosary in Homewood, St. Lawrence O'Toole in Bloomfield, and St. Aloysius in Wilmerding. The huge numbers of Catholic immigrants, their loyalty to their religion, and a natural gift for leadership led to the Irish control of the Church hierarchy in Pittsburgh and across the nation, a dominance that lasted well into the 20th century.

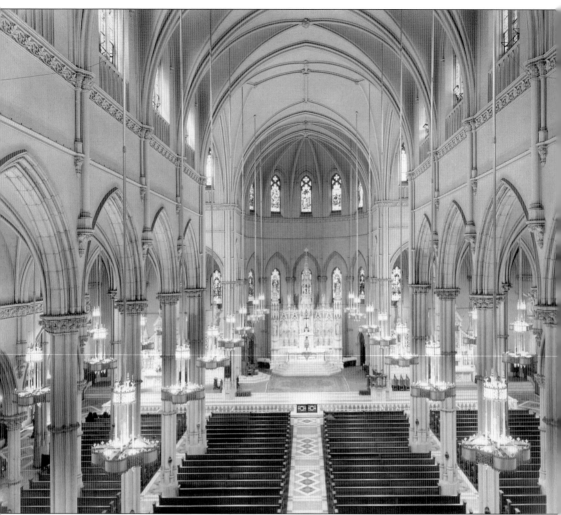

The spectacular interior of St. Paul's Cathedral in Oakland is seen here in the 1950s. Founded in 1843, St. Paul's was the second Catholic parish in the city. St. Paul's Church, as it was originally called, was located downtown on Grant Street and became a cathedral when Pittsburgh became a diocese. St. Paul's was relocated to Oakland and a new cathedral was dedicated on October 24, 1906. Even in its grandeur, St. Paul's was a parish church and, like other parishes, was the center of churchgoers' lives. Parishes also offered social and cultural activities to engage as many parishioners as possible in the church community. (Courtesy of Diocese of Pittsburgh Archives and Records Center.)

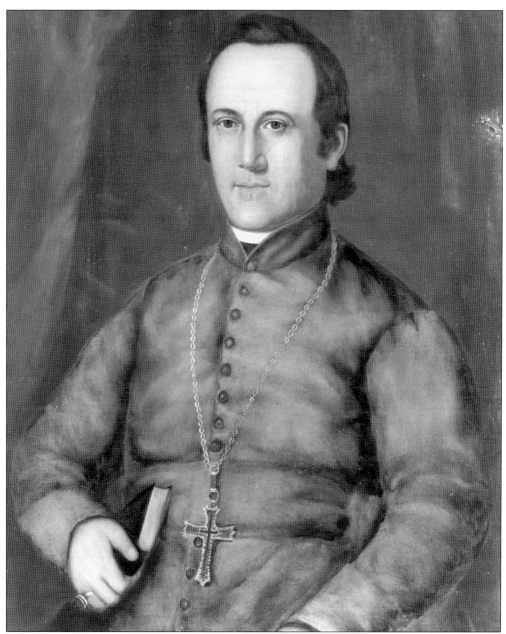

Michael O'Connor (1810–1872) was the first bishop of the Diocese of Pittsburgh, guiding the diocese through its formative years, which included dramatic change in the church and the nation. O'Connor was born in Cobh in County Cork and studied for the priesthood in France and Italy. After working as a missionary and educator, he was named pastor of St. Paul's Church in Pittsburgh. When the Diocese of Pittsburgh was created in 1843, O'Connor was appointed its first bishop and brought eight seminarians and seven Sisters of Mercy to the city. During his term in office, from 1843 to 1860, he helped increase the number of Catholic churches and members of clergy, and founded a seminary, a hospital, a girls' academy, an orphans' asylum, the *Pittsburgh Catholic* newspaper, and St. Michael's Seminary. (Courtesy of Diocese of Pittsburgh Archives and Records Center.)

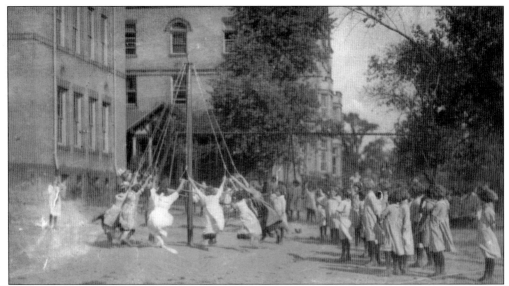

Girls swing on the grounds of St. Paul's Orphan Asylum, outside the city in Idlewood Station, around 1910. At the 1901 commencement ceremony, speaker John B. Head said that the rural site was intended to provide a wholesome setting for orphans: "It seems natural that during the period of infancy and helplessness, the sweet, pure countryside is the natural home of the child." (Courtesy of Archives of the Sisters of Mercy in Pittsburgh, 2010.)

Sister Eulalia reads to the children at St. Paul's Orphanage in Crafton in the 1940s. The Sisters of Mercy were critical to the survival of the Pittsburgh Irish. Led by Mother Frances Warde, the organization founded St. Paul's Orphanage, Mercy Hospital, and Mercy Academy, offering diverse programs for destitute women, children, and families. (Courtesy of Archives of the Sisters of Mercy in Pittsburgh, 2010.)

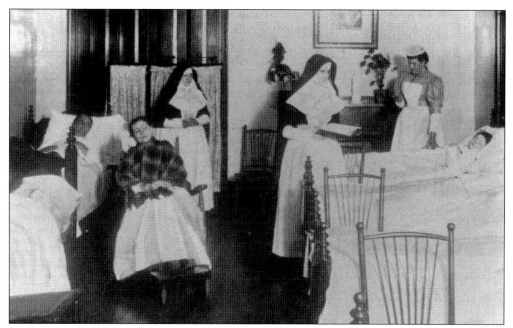

On January 1, 1847, the Sisters of Mercy opened the first hospital in western Pennsylvania in downtown Pittsburgh and welcomed patients, whether they could pay for their treatment or not. The sisters nursed immigrants and native-born Americans during outbreaks of smallpox, cholera, and typhus. The women's ward is shown here in the 1890s. Mercy Hospital later moved uptown. (Courtesy of Archives of the Sisters of Mercy in Pittsburgh, 2010.)

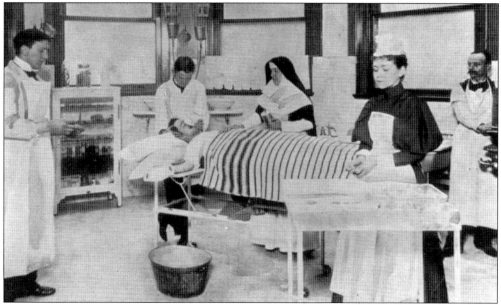

Nurses attend to a patient in Mercy Hospital's operating room in the 1910s. "These [charitable] activities," writes Dennis Clark in *The Irish in Pennsylvania*, "were the beginning of a huge transformation in which the Irish led the way for disadvantaged minorities in building a system of social welfare development at a time when government was all but absent from measures for relief of poverty." (Courtesy of Archives of the Sisters of Mercy in Pittsburgh, 2010.)

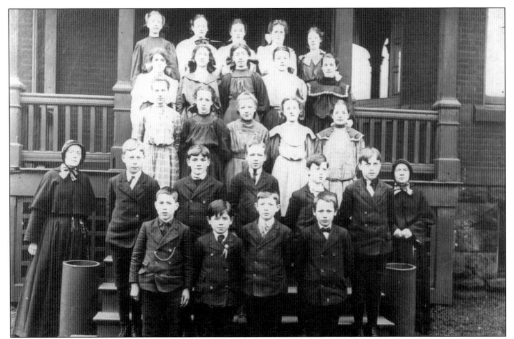

The class of Holy Cross High School, on the South Side, poses on the steps of the school in 1907. Sister Maria A. McLinden is on the left and Sister M. Stella Mulligan is on the right. Sisters of Charity taught at Holy Cross from 1886 to 1959. (Courtesy of Diocese of Pittsburgh Archives and Records Center.)

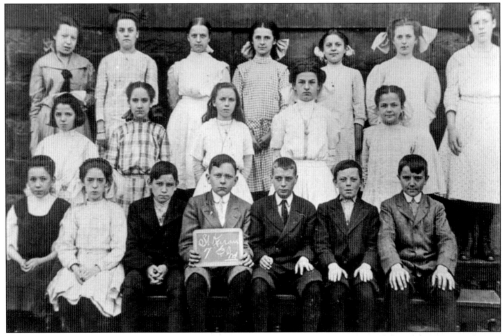

Sister Ambrosia Timon's seventh-grade class at St. Kieran's Grade School in Lawrenceville poses in 1913. In 1993, St. Kieran merged with St. Mary Assumption to form the new St. Matthew parish. (Courtesy of Diocese of Pittsburgh Archives and Records Center.)

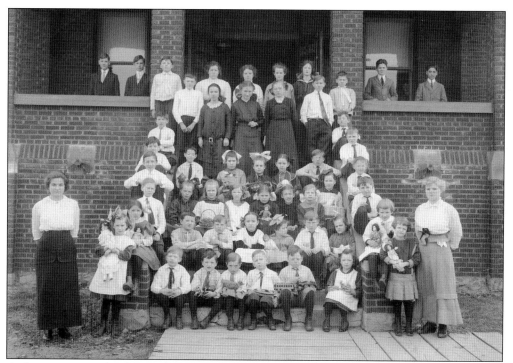

A class poses outside of DePaul Institute with two teachers in the 1910s. The North Side facility provided education for hearing and speech-impaired children. (Courtesy of Diocese of Pittsburgh Archives and Records Center.)

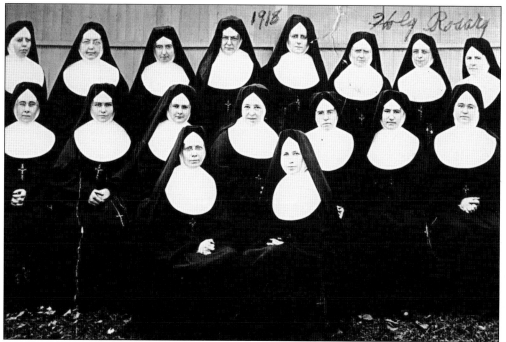

Sisters of Mercy faculty at Holy Rosary Catholic School in Homewood pose in this 1918 photograph. (Courtesy of Diocese of Pittsburgh Archives and Records Center.)

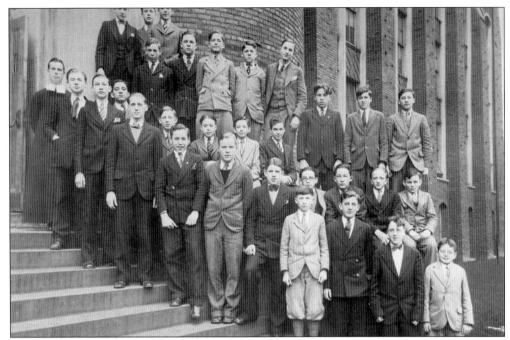

A 1930s class poses on the steps of Central Catholic High School in Oakland. (Courtesy of Diocese of Pittsburgh Archives and Records Center.)

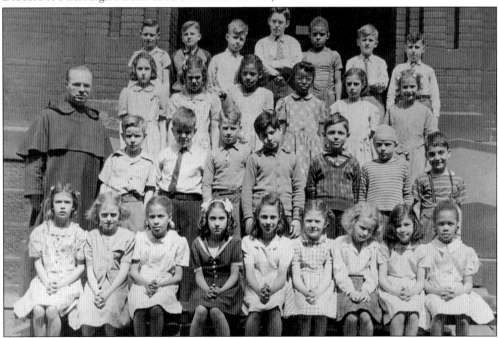

Students from grades three and four pose in 1946 at Holy Trinity School in the Hill District. Father Wilford is the priest at left. Holy Trinity was originally a German parish, but in the early 1900s, parishioners started moving from the Hill District and its makeup changed. In 1958, Holy Trinity merged with St. Brigid's Church and took the latter's name. (Courtesy of Diocese of Pittsburgh Archives and Records Center.)

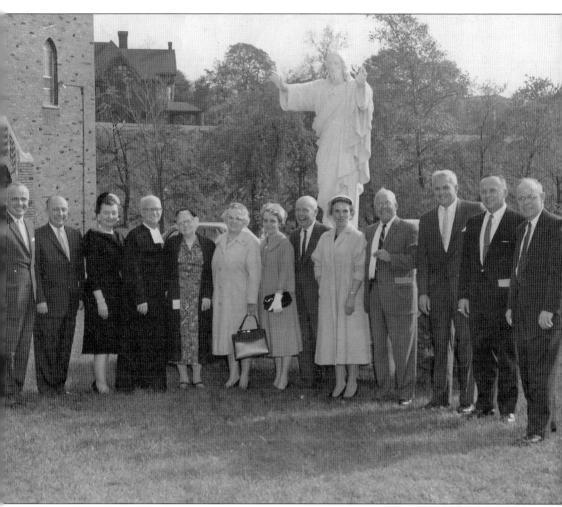

Irish Catholic families took particular pride in their sons becoming priests or brothers. Clergymen were revered in Catholic communities as spiritual guides, confessors, and teachers. John Francis McGough (1911–1983) was a member of the first graduating class at Central Catholic High School in Oakland in 1931. After graduation, he joined the Christian Brothers and took vows as Brother Fabrican Benedict, FSC. He taught school in Canton, Ohio, and in Philadelphia before returning to Pittsburgh after his father died in 1950 to be close to his mother. Assigned to his alma mater, Brother Fabrican taught English and other courses at Central Catholic for more than 30 years. In this October 28, 1961, photograph, friends and family of Brother Fabrican (fourth from left) celebrate his silver jubilee as a Brother of the Christian Schools on the lawn at Central Catholic. (Courtesy of Quigley family.)

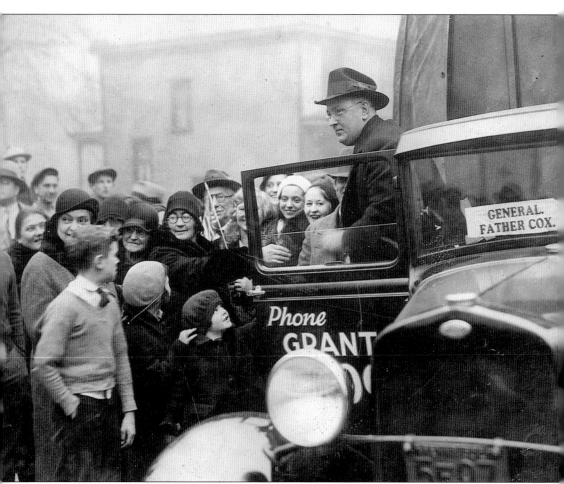

The remarkable Rev. James Renshaw Cox (1886–1951) led a march of more than 12,000 jobless men from Pittsburgh to Washington, DC, in January 1932 to demand a public works program for unemployed Pennsylvanians. Shown here flanked by his followers in his car during the march, Father Cox led "Cox's Army" to the largest demonstration ever held in Washington at the time. Cox was born in Lawrenceville, attended Duquesne University and the University of Pittsburgh, and served as pastor of St. Patrick's Church in the Strip District. During the Great Depression, he set up a soup kitchen and provided temporary shelter for the poor. When the 1932 march failed to produce a jobs program, the priest decided to run for president under the banner of the newly created Jobless Party. In September 1932, he canceled his campaign and threw his support to Pres. Franklin D. Roosevelt. Dubbed Pittsburgh's "Pastor of the Poor," he spent the rest of his life ministering to the needy. (Courtesy of Dr. and Mrs. Mason, Father James Renshaw Cox Collection, Saint Patrick-Saint Stanislaus Kostka parish, Pittsburgh, PA.)

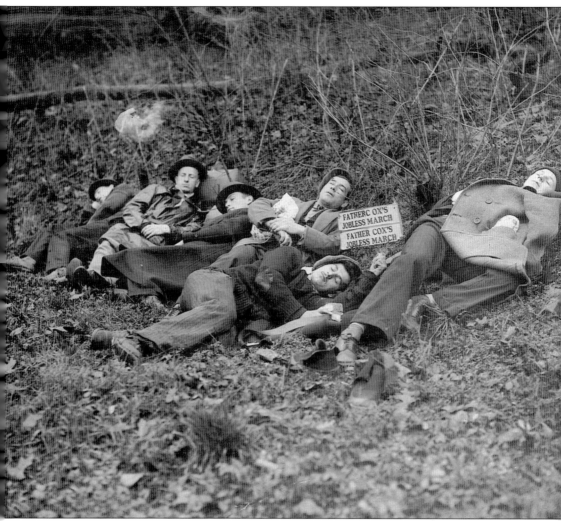

Although 2,500 men were expected to participate in the jobless march, 25,000 people actually arrived in Pittsburgh in January 1932. Approximately half of them then hopped onto cars and trucks and began the trek to Washington. By January 7, a total of 2,000 vehicles, carrying 12,000 protesters, had entered the capital. Washington police found the men to be orderly and created field kitchens to feed them coffee, milk, doughnuts, and apples. These men rest on a hillside during the march, possibly in the government-owned lots in southwest Washington that were provided for the protesters. Pres. Herbert Hoover was not sympathetic to the marchers but, when he learned that 30 percent of them were military veterans, he agreed to meet briefly with Father Cox. Unfortunately, he did nothing to help "Cox's Army" and they returned to Pittsburgh empty-handed. The shantytown in Lawrenceville where some of the men lived had been razed by Pittsburgh police during their absence and they were now homeless. (Courtesy of Dr. and Mrs. Mason, Father James Renshaw Cox Collection, Saint Patrick-Saint Stanislaus Kostka parish, Pittsburgh, PA.)

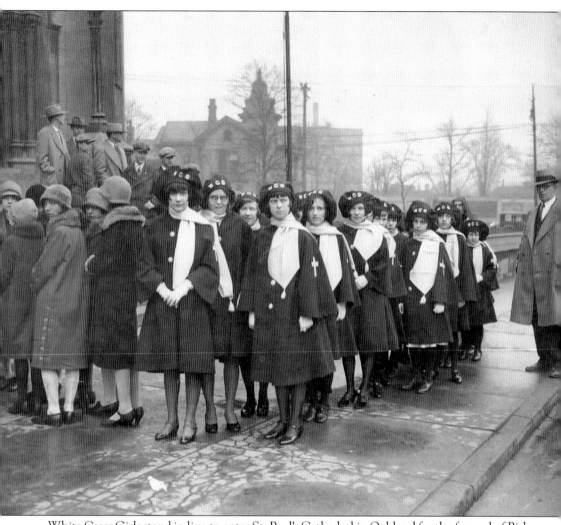
White Cross Girls stand in line to enter St. Paul's Cathedral in Oakland for the funeral of Bishop J.F. Regis Canevin in 1927. (Courtesy of Diocese of Pittsburgh Archives and Records Center.)

First Holy Communion was a special occasion for seven- and eight-year-old Catholics. It marked their initiation into the sacrament of the Holy Eucharist, their symbolic receiving of the body and blood of Jesus Christ. At right, James Tighe stands in front of the war memorial of St. Mary of the Mount Church in Mount Washington on his First Holy Communion Day in the 1930s. His fresh white suit was the required dress, and his knickers reflect the fashion of the era. Below, Catherine Riley, also from St. Mary of the Mount, wears the white dress and veil traditional for girls taking the sacrament for the first time. Staring solemnly at the camera, she clutches flowers to her heart. (Both, courtesy of Patricia Moorhead.)

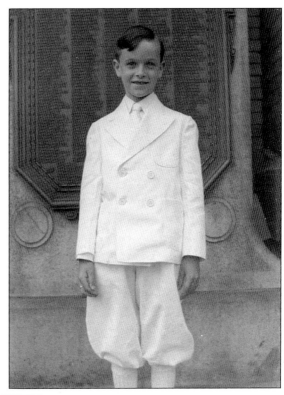

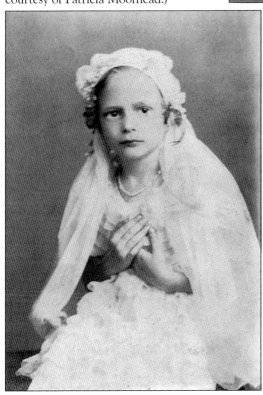

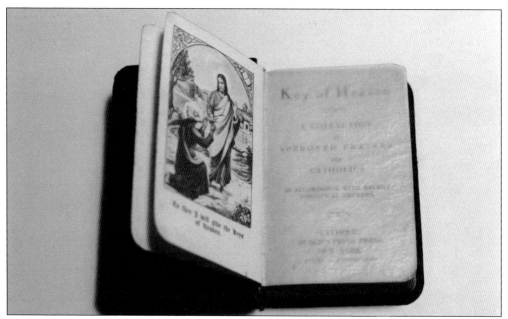

The Catholic missal was an important part of a worshipper's life. The missal above, belonging to Mrs. John James McElligott in 1931, contains prayers that may be offered throughout the day—morning and evening prayers plus daily devotions—as well as prayers at Mass, penance after confession, vesper service, benediction, and Stations of the Cross. Religious duty was important to Irish Catholics and many of them attended Mass every day. One page of this missal features the Table of Movable Feasts, feast days on the Catholic calendar for the years 1931 to 1946. A second missal (below), from 1953, was "written especially for boys and girls who are longing to receive Jesus in the Blessed Sacrament for the first time." It was given to children to prepare them for their First Holy Communion. (Photographs by Amy Pischke.)

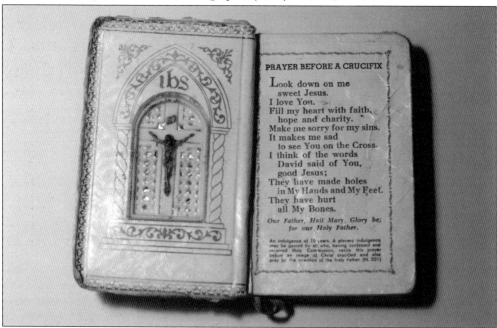

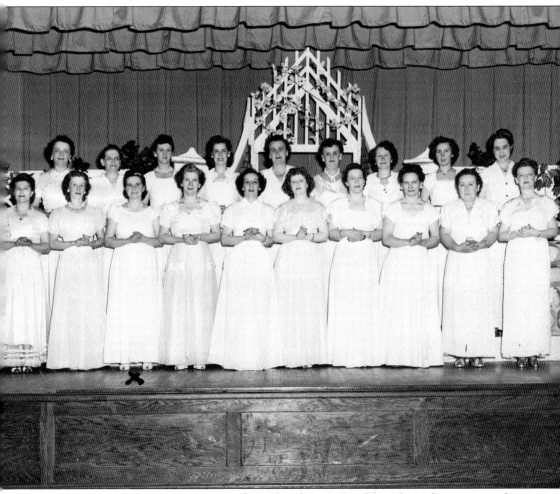

St. Anselm's Choral Group, from St. Anselm's Church in Swissvale, performed at programs for the parish and in nursing homes. The all-female group poses in this 1950s photograph. Geraldine O'Neil was the leader and organizer of the group and also served as the librarian of the Pittsburgh Irish Centre. (Courtesy of M.F. Garrison.)

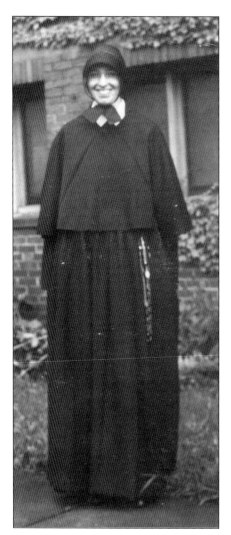

Catholic families prized any daughter who became a nun. Sister Mary Bernard, seen here around 1955, grew up as Margaret Ruth O'Brien in Lawrenceville. At 16, she entered the Noviate at Seton Hill in Greensburg and took her vows as a Sister of Charity on August 15, 1927. Sister Bernard taught in various Catholic schools in the diocese, including St. Luke High School, where she later became principal. (Courtesy of Timothy Daniel O'Brien.)

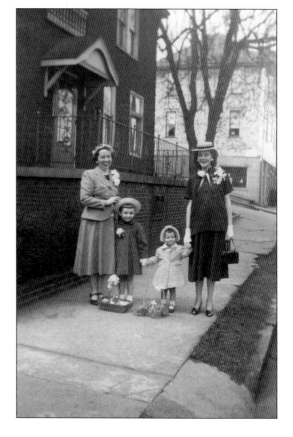

Dressed in spring outfits and Easter hats, a Catholic family celebrates Easter Sunday in 1953. From left to right, they are Claire Feeney O'Connor, Mary Claire O'Connor, Anne Feeney, and Annabelle Feeney. The Feeneys lived in Charleroi and moved to Brookline later that year. (Courtesy of Anne Feeney.)

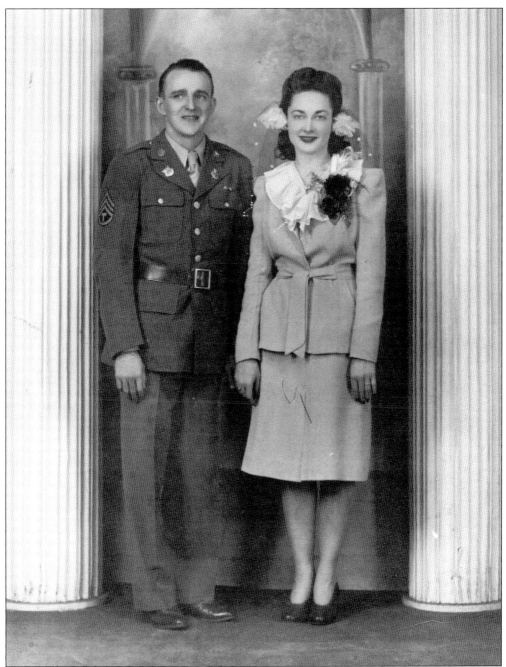

John J. McElligott and Margaret Martin married on May 4, 1944, at St. Brigid's Church in the Hill District during John's leave from the Army. Like many Irish American couples, they postponed having families until the war ended and John returned to Pittsburgh for good. After the wedding and a brief honeymoon, he returned to active duty in the European theater and remained until the end of the war. The couple had their first child, John, in 1946. (Courtesy of McElligott family.)

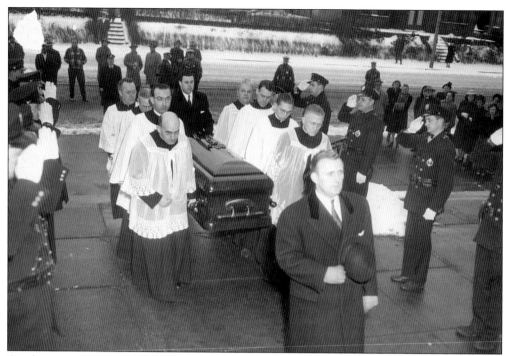

On the steps of St. Paul's Cathedral in Oakland, Bishop John Dearden and Father Francis Burke lead the procession at the funeral of Bishop Hugh C. Boyle on December 27, 1950. (*Pittsburgh Press* photograph, courtesy of Diocese of Pittsburgh Archives and Records Center.)

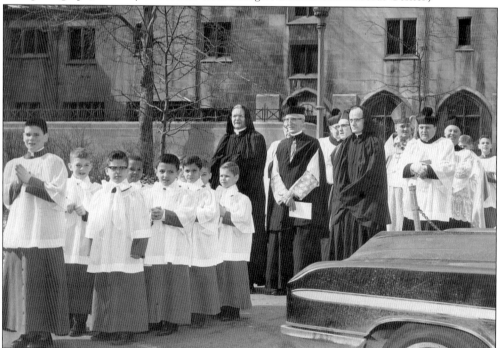

Altar boys participate in the Investiture of Papal Knights in the 1960s at St. Paul's Cathedral in Oakland. (Courtesy of Diocese of Pittsburgh Archives and Records Center.)

Bishop John Dearden (1907–1988) speaks at the Parish Golden Jubilee Dinner in 1957 at St. Paul's Cathedral in Oakland. Dearden was bishop of Pittsburgh from 1950 to 1958. Among his accomplishments was permitting interfaith marriages between Catholics and non-Catholics to take place in the church. (Courtesy of Diocese of Pittsburgh Archives and Records Center.)

John Joseph Wright (1909–1979), seen below in 1969 leading a group prayer in Swissvale, was the eighth bishop of Pittsburgh and later a cardinal in the Catholic Church. Bishop Wright was a conservative theologian who was liberal on social issues. A generation of Pittsburgh children had fond memories of the witty bishop performing confirmation in their parish churches. (Courtesy of Irish Centre of Pittsburgh.)

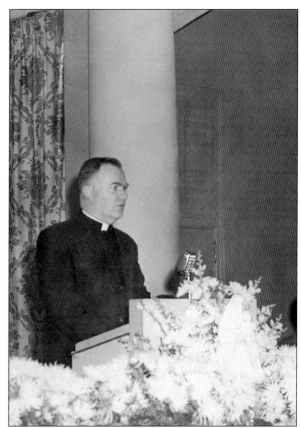

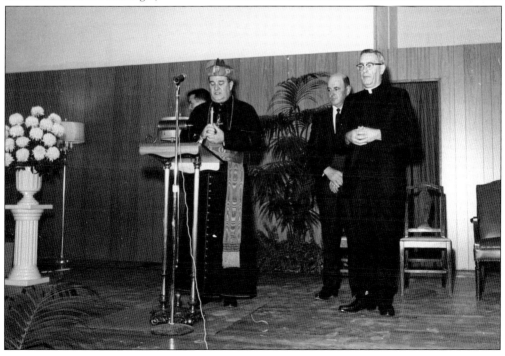

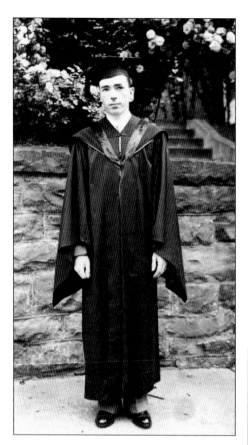

Edward J. Feeney of Brookline is seen here in his commencement robes on his graduation from Duquesne University in 1931. The university was created by the Congregation of the Holy Spirit in 1878 as the Pittsburgh Catholic College of the Holy Ghost. In 1911, it became a university—the first Catholic post-secondary institution in Pennsylvania to receive that distinction. It now hosts over 10,000 students on its Bluff campus. (Courtesy of Anne Feeney.)

Prayer cards were distributed to the Catholic faithful in Pittsburgh to allow them to recite a prayer any time during the day. This card, "Special Prayer to the Queenship of Mary," published in November 1954, exalts the Blessed Mother: "We raise our eyes to you, Most Beloved Mother Mary, to be comforted by the contemplation of your glory." (Courtesy of McElligott family.)

Five
SOCIAL LIFE
"BACON AND TEA"

There were lashings of punch and wine for the ladies,
Potatoes and cakes; there was bacon and tea,
There were the Nolans, Dolans, O'Gradys
Courting the girls and dancing away.

<div style="text-align: right">From "Lanigan's Ball"
Traditional Irish Folk Song</div>

The Irish are famously sociable people and Irish Pittsburghers live up to the reputation. They sing, they dance, they eat and, of course, they drink. Early on, the saloon became a key meeting place for Irish immigrants—the men, that is—a place where a man could not only wet his whistle but also find employment, plan political strategy, and hash over the news of the day. Pittsburghers in the late 1800s and early 1900s held socials, picnics, and dances. In every venue, they told stories in their inimitable fashion, spreading the blarney along with the music and drink.

As the Irish became Americanized in the 1900s, their enthusiasm for their Irish heritage waned in favor of American pleasures, but a resurgence of interest in Irish culture throughout the country in the 1960s led to the creation of numerous Irish-themed organizations and businesses, including the Irish Centre of Pittsburgh, the Ireland Institute of Pittsburgh, the American Ireland Fund, the Pittsburgh Irish Festival, the Echoes of Erin radio program, Irish pubs, dance schools, the Irish Design Center, St. Brendan's Crossing, the Pittsburgh Irish Rowing Club, and the Pittsburgh Irish and Classical Theatre. And, of course, Irish Pittsburghers never lost their love of good times, Gaelic music, stiff drink, and blarney. Slainte!

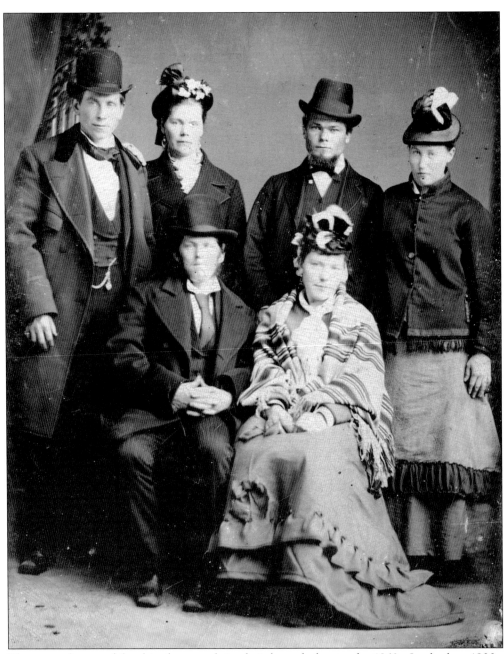

Three couples posed for this photograph in their best clothes in the 1860s. In the late 1800s, Pittsburghers attended plays, band concerts, community-sponsored picnics, and socials during their free time. The quality of this group's clothing, with top hats, watch fobs, and velvet collars, strongly suggests that they were not famine immigrants. The men may have held jobs as clerks or owned small businesses and were sufficiently well-heeled to have a tintype made. By the late 1850s, tintypes, a new technology, made photography affordable to average citizens for the first time. (Courtesy of Hays family.)

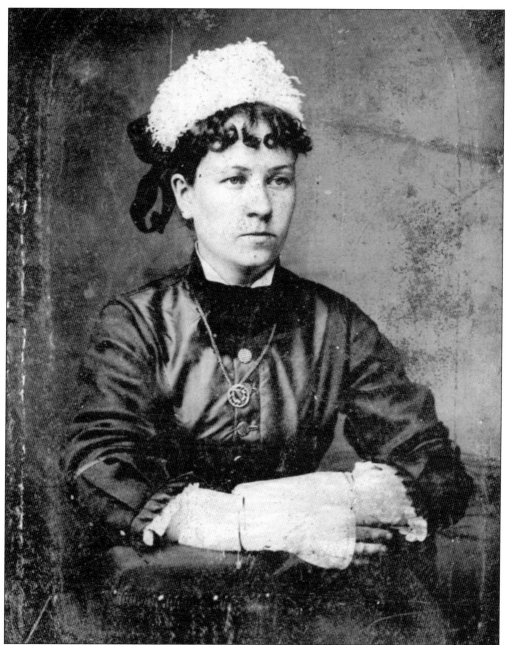

In one way, Irish domestic workers were fortunate, since their basic needs for housing, food, and clothing (uniforms) were provided by their employers. For the first time in their lives, many of these women had disposable income. After sending money home to their families in Ireland, Irish Pittsburghers could spend their earnings on clothing, a new experience for women who had grown up shoeless on farms in Tralee or Galway. As early as 1860, observers noted the refined dress of Irish working women, like the woman in this 1860s photograph. Spending money on one's self was routinely condemned by critics who felt that extra income should be donated to the Catholic Church, but this simple indulgence was a step toward independence for Irish American women. (Courtesy of Hays family.)

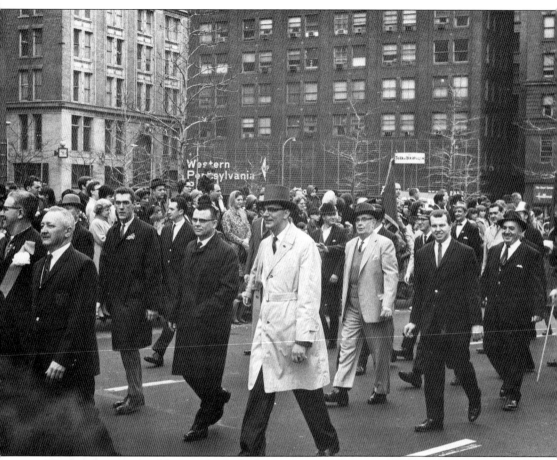

The most boisterous celebration for the Irish community is the annual St. Patrick's Day parade. Over 150,000 Irish and "Irish-for-a-day" Pittsburghers turn out in dazzling shades of green to celebrate their heritage, including marching groups, bands, politicians, and celebrities. The Ancient Order of Hibernians started the parade in 1869; today, more than 23,000 people march or ride in the event every year. Here, members of the AOH, Division No. 34, from Homestead, march along Liberty Avenue downtown in the 1967 parade. (Courtesy of Larry Squires.)

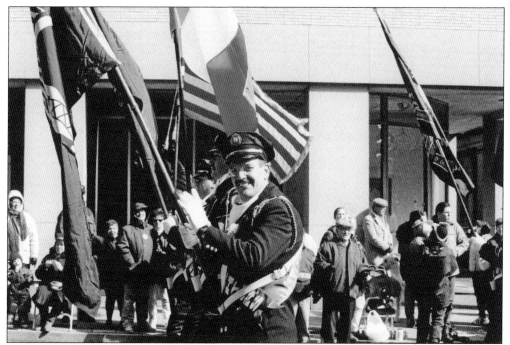
Members of the City of Pittsburgh Fire Bureau carry Irish and American flags in the 1998 parade. The city's police and fire departments were always well represented in the St. Patrick's Day celebrations because so many of their members were of Irish descent. (Photograph by Carmen J. DiGiacomo.)

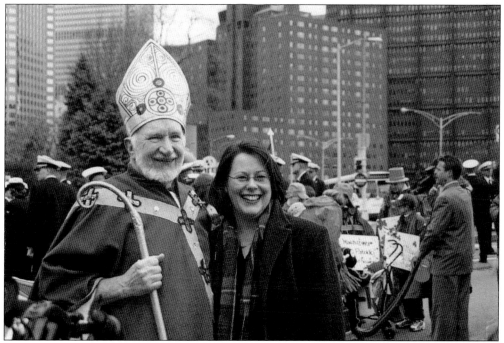
St. Patrick poses with Michelle Gildernew, a Sinn Fein member of the legislative assembly in Northern Ireland, in the 2001 parade. (Photograph by Carmen J. DiGiacomo.)

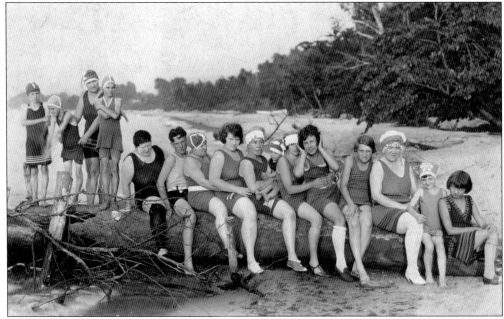

By the early 1900s, better jobs and better pay meant that Irish Pittsburghers could afford vacations. This bevy of women and children outfitted in the clinging suits of the 1920s enjoy a day at the beach, probably Lake Erie. Vacationers often converted photographs of themselves—comical and otherwise—into postcards like this one and mailed them to friends and family. (Courtesy of McElligott family.)

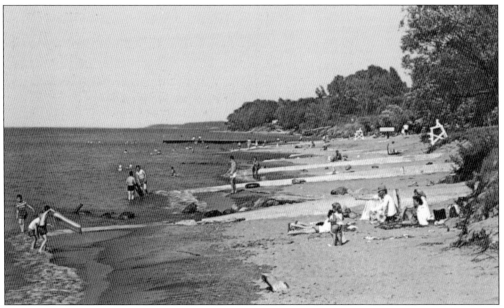

Lake Erie became the vacation spot of choice for many Irish Pittsburghers, especially in post–World War II households with growing families. This 1950s-era postcard shows the beach at Geneva-on-the-Lake, Ohio. Friends and families rented small cottages and enjoyed an inexpensive hiatus from the city. (Courtesy of McElligott family.)

Pittsburghers enjoyed a respite from smoky skies by picnicking in the countryside. In this 1920s photograph, Agnes McElligott of the Hill District poses with her son, Charles, and two girls holding parasols to protect their skin from the sun. (Courtesy of McElligott family.)

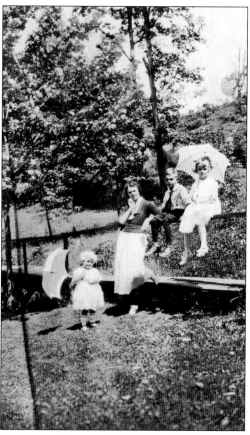

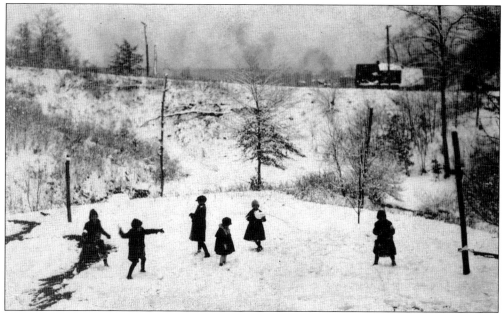

These children play in the snow in the city in the 1920s, offering a startling contrast to the smoke rising from the steel mills in the far background. (Courtesy of McElligott family.)

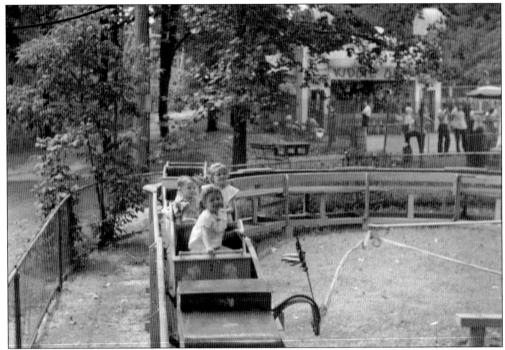

Irish Day at the Kennywood amusement park in West Mifflin was an annual ritual for many Pittsburgh families, who took their homemade lunches to the picnic shelters by the Jack Rabbit roller coaster or the little railroad and made a day of picnicking, riding, and celebrating their Irish heritage. Here, three children bump along on a miniature coaster in Kiddy Land in 1949. (Courtesy of McElligott family.)

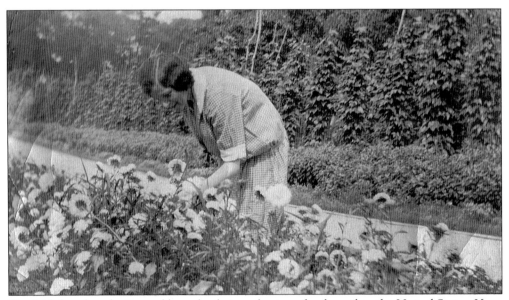

The Irish loved gardening and brought their enthusiasm for the soil to the United States. Here, Bridie McInerney leans over the flowers in her backyard garden in Homewood around 1925. (Courtesy of John E. McInerney.)

These two young men dressed up in their good suits, shirts with celluloid collars, and high button shoes in the 1910s. They may have been headed for a good time at the local saloon. Drinking was a glorious pastime for the Irish, especially men, but alcoholism was a serious problem across the country. (Courtesy of McElligott family.)

Like many Americans, Irish Pittsburghers fell in love with the automobile. Below, Michael O'Shea stands next to his Ford Model T around 1930 on a Sewickley estate, where he worked as a caretaker. The Model T was a breakthrough development because it made car ownership affordable to middle-class Americans for the first time. Michael sold his Model T in 1933 to pay for his honeymoon. (Courtesy of Eileen Aquiline.)

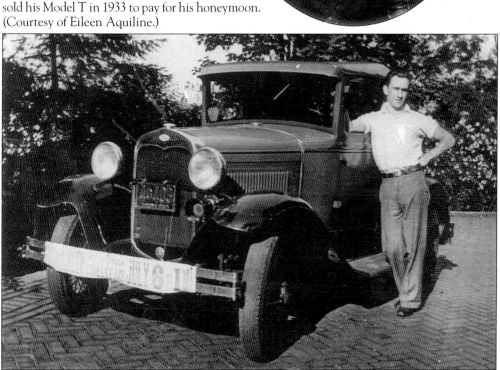

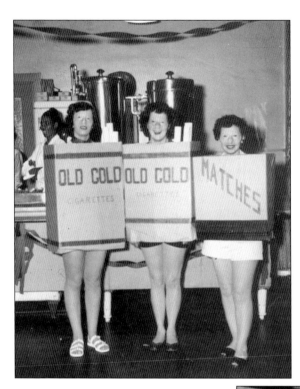

Illness did not stop Pittsburghers from celebrating. While she was recuperating from tuberculosis at Leech Farm Tuberculosis Sanitarium in 1953 and 1954, Shirley Griffin O'Brien (center) and two fellow patients dressed up for a Halloween party at the East Liberty facility by decorating cardboard boxes with the names of Old Gold cigarettes and matches. (Courtesy of Timothy Daniel O'Brien.)

Singing came as naturally to the Irish as breathing. In this photograph from the late 1970s, David Figgins, a tenor, performs a St. Patrick's Day concert at the Fellows Club, a social group that gathered in the basement of the LeMont Restaurant on Mount Washington. Figgins, an engineer from the North Side, was always willing to sing at the drop of a hat. (Courtesy of David F. Figgins.)

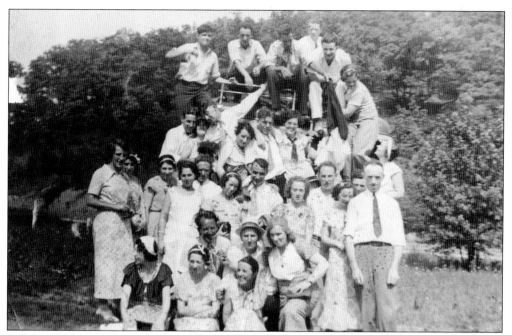

Irish Pittsburghers created opportunities to get together frequently. Here, the All Ireland Athletic Club holds a picnic in North Park in the early 1930s. The club, which still exists, held monthly socials where members sang and danced to Irish music. (Courtesy of Eileen Aquiline.)

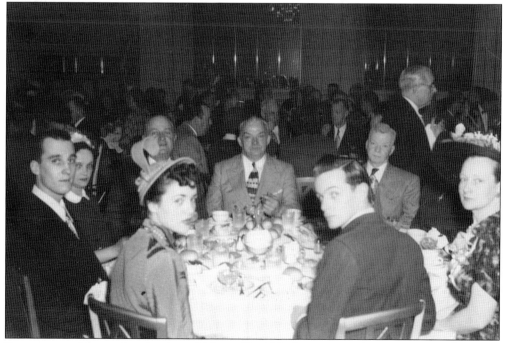

Supporters celebrate the election of Mayor David L. Lawrence at his swearing-in dinner in 1945 at the William Penn Hotel. Sitting at the front of the table are Nancy Tighe, her twin brother James Tighe, and, on the right, their parents, Kitty and John P. Tighe. (Courtesy of Patricia Moorhead.)

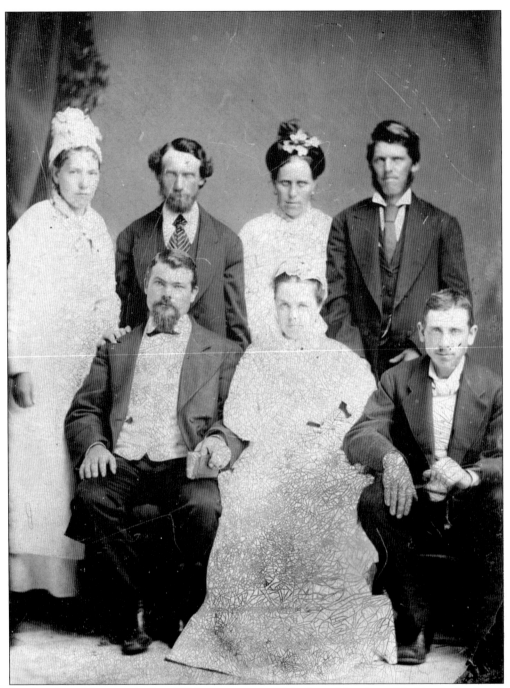
Pittsburgh weddings in the late 1800s were opportunities for celebrating with friends, food, and drink—for those who could afford them. This sober wedding party in the 1860s would have celebrated the marriage in church, then gone to a restaurant or a home for a meal or a party. (Courtesy of Hays family.)

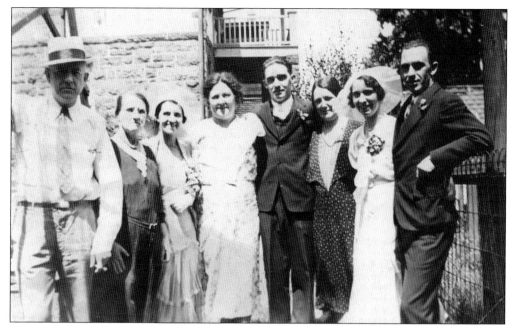

Family and friends gather in a Homewood backyard to celebrate the marriage of Nora Stack (second from right) and Michael O'Shea (far right) on June 15, 1933. The guests include, from left to right, Mark Davin, Aunt Julie, Mary Stack, Bertha Davin, Cornelius Stack, and May Healy. (Courtesy of Eileen Aquiline.)

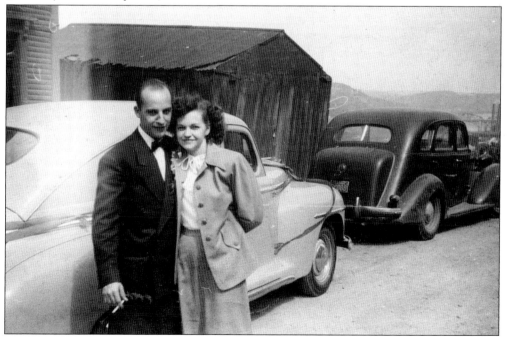

Jack Murphy and Elizabeth McElligott are seen here in the Hill District after their wedding in 1948. The large numbers of post–World War II weddings created the "Baby Boom" phenomenon and Pittsburgh was no exception. The Murphys had three children and lived in Castle Shannon and Baldwin. (Courtesy of McElligott family.)

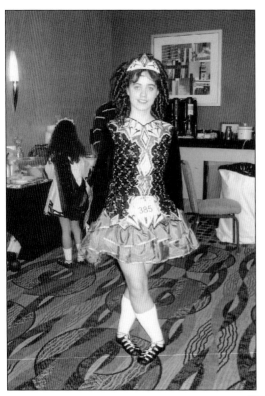

Alana Garrison, a 13-year-old from Freedom, participates in the Pittsburgh Irish Fesh dancing competition on January 1, 2011. Garrison is a third-generation step dancer and a student at the Bell School of Irish Dance. Traditional Irish dancing has become increasingly popular in Pittsburgh and all over the country. (Courtesy of M.F. Garrison.)

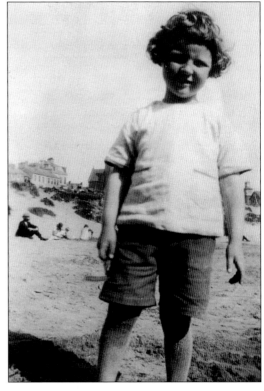

North Side resident David Figgins, seen here in 1929, remembered Christmas dinner when he was a boy. His father would pour brandy over plum pudding for a flaming dessert and "one Christmas the brandy wouldn't light. My father bent down and sniffed it, then asked, 'Who drank the brandy?' My brother went very red in the face and confessed to having drunk half the bottle and then filled it up with water. He got no plum pudding that year." (Courtesy of David F. Figgins.)

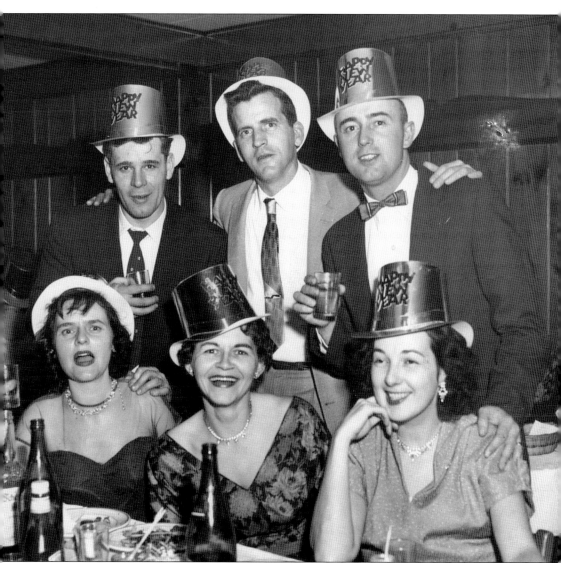

New Year's Eve was always a prime occasion for celebrating. This happy group at Pat McBride's Supper Club on the North Side poses for a photograph on December 31, 1953. James and Anne Trenz are the couple in the middle, and Timothy O'Brien and his wife, Shirley, are on the right. The couple on the left is unidentified. Trenz and O'Brien were patrolmen with the Pittsburgh Police Department. (Courtesy of Timothy Daniel O'Brien.)

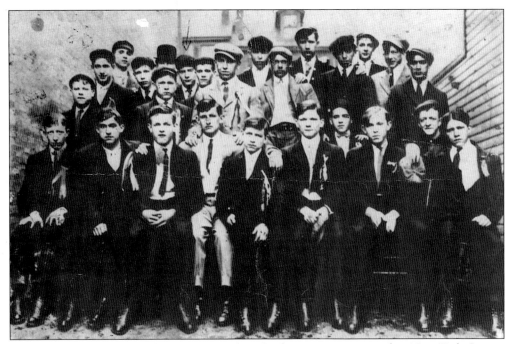

The American division of the Ancient Order of Hibernians was created in New York City in 1836 to protect Catholic clergy from attacks by native-born Americans. It also provided relief to the immigrants who flooded into the United States in the decades following the Great Potato Famine. New divisions were chartered throughout the country. The first Pittsburgh chapter of AOH—Division No. 1, South Side—opened in 1850. Division No. 23 was chartered in Lawrenceville in 1903. Above, members of Division No. 23 pose for a photograph in 1908. Below, members of the same division pose in 1946. (Both, Courtesy of Dan Drischler.)

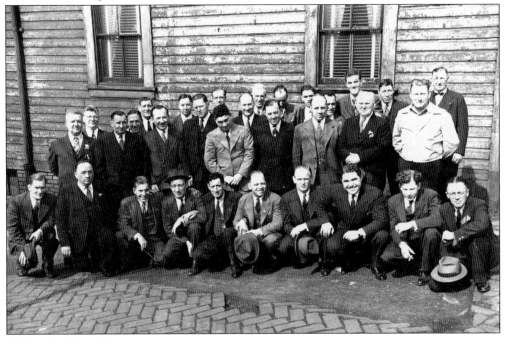

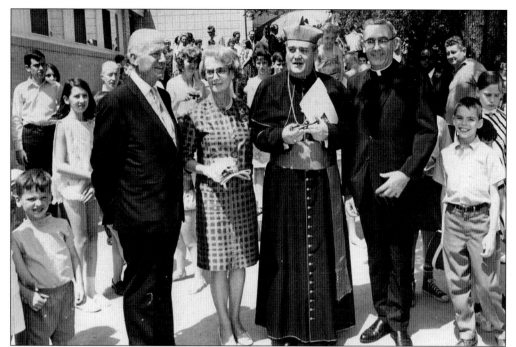

On January 3, 1966, Rev. Patrick J. McCarthy and other enthusiasts met in Mary and Francis Clark's Wilkinsburg home to create a center that would offer Gaelic-inspired lectures, classes, and live performances to the community. Over tea and Irish soda bread, the group founded the Irish Centre of Pittsburgh. The community rallied around the effort, located a property on Forward Avenue in Squirrel Hill, and built the center's facility. Seen above at the May 30, 1969, dedication of the building are, from left to right, William Fay, the Irish ambassador to the United States; his wife, Lillian; John Cardinal Wright; and Father McCarthy. Below is the plaque that commemorated the event. The center is still located in this building. (Both, courtesy of Irish Centre of Pittsburgh.)

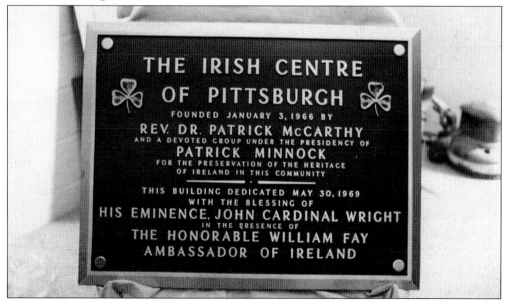

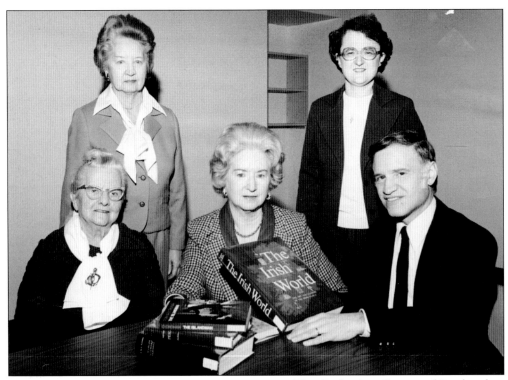

The Gaelic Arts Society of Pittsburgh offers *cead mile failte*, or "100,000 welcomes," to anyone who is interested in Ireland's culture. Founded in 1955, the society promotes Irish culture and the Gaelic language. In the 1979 photograph above, members reviewing new books are, from left to right, (sitting) Mary Clark, Bernadette Maloney, and an unidentified man; (standing) Margaret Maloney and an unidentified woman. (Courtesy of Irish Centre of Pittsburgh.)

Fag An Bealach: The Irish Contribution to America and in particular to Western Pennsylvania was published in 1977 as part of the United States bicentennial. During the bicentennial, Pittsburghers honored Irish contributions to life in the region, including laying a wreath on the Allegheny River to commemorate Revolutionary War heroes of Irish descent. (Courtesy of Edward Deenihan.)

The Irish Nationality Room at the University of Pittsburgh, seen here in 1979, was financed by contributions from Irish Pittsburghers over a 30-year period. Modeled on a 12th-century oratory from Ireland's Golden Age, the classroom is inscribed with the Gaelic motto: "For the glory of God and the honor of Ireland." A container of earth from southern and northern Ireland lies behind the cornerstone. (Courtesy of John Haltigan.)

Irish Pittsburghers raised money for countless organizations with Gaelic roots. Here is the program for "Livin,' Lovin' and Foolin' Around," a 1960s concert sponsored by the Irish Room Committee at the University of Pittsburgh and the Gaelic Arts Society to fund the John F. Kennedy Scholarship Award for a student to study in Ireland for the summer. The songs included "Trottin' to the Fair" and "Gortnamona." (Courtesy of David F. Figgins.)

"LIVIN', LOVIN' AND FOOLIN' AROUND"

FEATURING

DAVID F. FIGGINS TENOR

MARGARET MARY COLEMAN ACCOMPANIST

A

GALA BENEFIT CONCERT

SPONSORED BY

THE IRISH ROOM COMMITTEE

UNIVERSITY OF PITTSBURGH

AND

THE GAELIC ARTS SOCIETY OF PITTSBURGH

FOR THE

JOHN F. KENNEDY SCHOLARSHIP AWARD

FOR SUMMER STUDY IN IRELAND

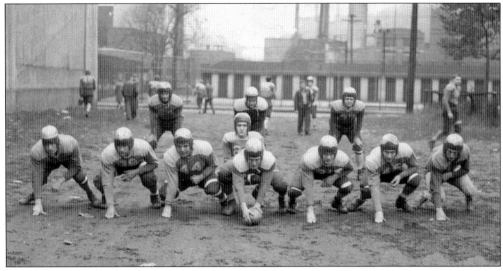

Like their fellow Pittsburghers, the Irish loved football. A group of friends, most of them veterans of World War II, formed the Shamrocks sandlot football team in 1947 in the Lawrenceville area and played in fields throughout the city. Timothy O'Brien, at the far left in this 1947 team photograph, played end. Note the mills in the far background of this Lawrenceville lot. (Courtesy of Timothy Daniel O'Brien.)

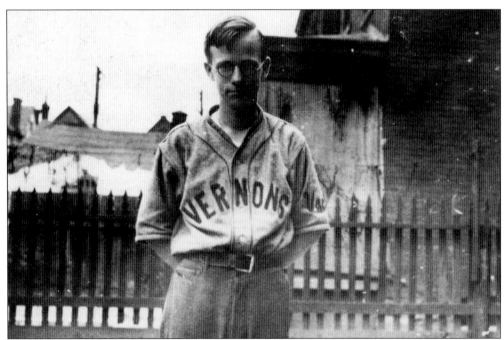

Baseball was also popular. John Francis McGough, seen here in his uniform in the late 1920s, played for the Vernons baseball team. The Vernons were a Pittsburgh team from the East End, probably Homewood. McGough grew up on Idlewild Street in Homewood and later became a Christian Brother. (Courtesy of Quigley family.)

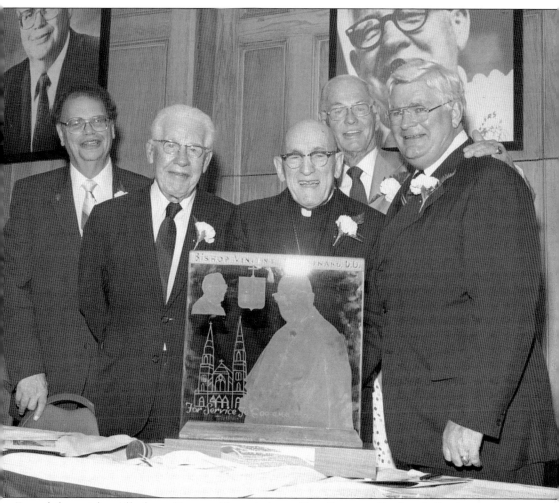

From left to right, Allegheny County Commissioner Tom Foerster, Pittsburgh Steelers owner Art Rooney, Bishop Vincent M. Leonard, Pittsburgh Pirates announcer Bob Prince, and an unidentified man celebrate at a testimonial for the bishop in the 1970s. (Courtesy of Diocese of Pittsburgh Archives and Records Center.)

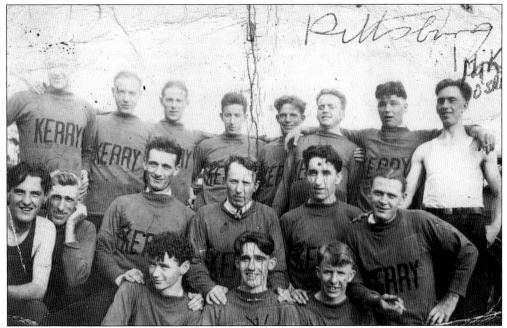

In 1930, local immigrants and their children created the All Ireland Athletic Club to promote traditional Irish sports. Seen here in the 1930s, with Michael O'Shea in the upper right corner, club members played Irish football and hurling. (Courtesy of M.F. Garrison.)

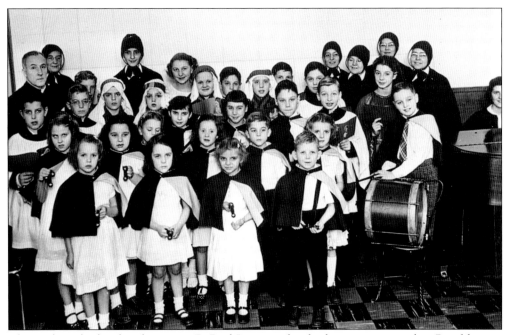

The student rhythm band poses at DePaul Institute for the hearing impaired in Brookline in the 1940s. Peggy Collins sits at the piano. In the rear, from left to right, are Father Doherty and Sisters Teresa Vincent, Justin, Francis Louise, M. Lois, John Agnes, and Mary Linus. (Courtesy of Diocese of Pittsburgh Archives and Records Center.)

Six
THE MILITARY
"A Soldier's Song"

*We're children of a fighting race
That never yet has known disgrace
And as we march, the foe to face
We'll chant a soldier's song.*

From "A Soldier's Song"
Ireland's national anthem

Renowned for their fighting spirit, nationalism, and patriotism, Irish Pittsburghers cut a wide swath in battle throughout this nation's history. They rebelled against the British during the Revolutionary War—more than half of the Pennsylvania members of George Washington's Continental Army were Irish. During the Civil War, the Pennsylvania 102nd Regiment included many soldiers from the Pittsburgh area. In 1864, under the direction of Gen. Jubal Early, the regiment repelled the Confederate attack on Washington, DC.

Irish Pittsburghers marched into Berlin in World War I and Paris in World War II. The first generations of Irish Americans were fierce nationalists who advocated for Ireland's separation from Great Britain, a feat that was achieved in 1921. The following toast, often made by the Irish and their American cousins, sums up their attitude toward freedom: "May the harp be tuned to independence and be touched by skillful hands."

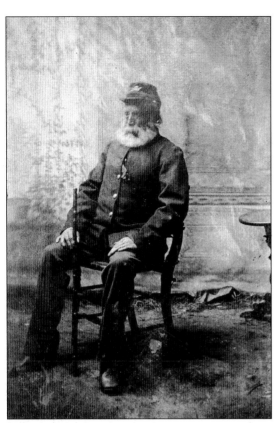

This veteran from an earlier era poses for a photograph in the early 1860s. He would have been too old to serve in the Civil War, although the oldest soldier to fight on the Union side was reputed to be a 50-year-old Irishman from the North Side. Irish men were renowned for their toughness. (Courtesy of Hays family.)

The memorial below in Allegheny Cemetery commemorates the 78 employees killed in the September 17, 1862, explosions at the Allegheny Arsenal in Lawrenceville. Victims were blown to bits or burned beyond recognition. The dead, many of whom were Irish immigrants, were buried in a deep pit, and the Rev. Richard Lea eulogized the "noble Union girls." For Pittsburghers, the incident was an unnerving reminder that civilians could also be victims of war. (Courtesy of John Haltigan.)

Michael McInerney, seen in his backyard in Homewood in 1936, served in the Irish Republican Army during Ireland's War of Independence. When independence for the newly named Irish Free State was won in 1921, McInerney knew it was time to emigrate. He wanted no part of the civil war that was brewing. "I did not join up to fight fellow Irishmen," he told his children. He left Ireland on April 30, 1922, and moved to Pittsburgh. (Courtesy of John E. McInerney.)

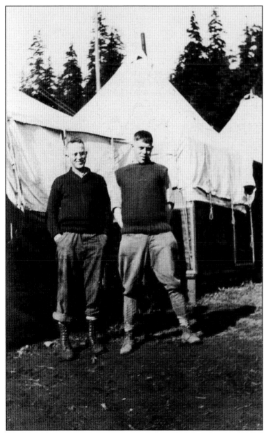

Frederick Hays (left) of Verona poses here with a friend in front of their tent. Hays served in the US Army in World War I. He survived the war, only to be killed in a work accident in the 1930s. (Courtesy of Hays family.)

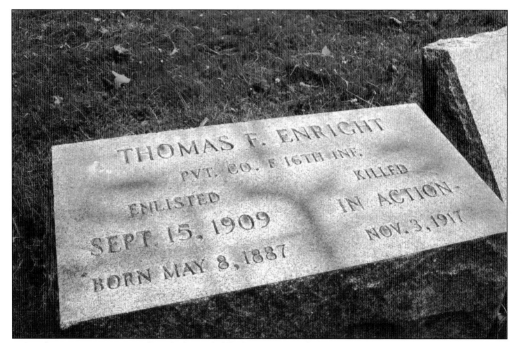

Pvt. Thomas Francis Enright of Bloomfield, the son of Irish immigrants, was one of the first three Americans to be killed in combat in World War I. On November 3, 1917, German troops raided their position in the Lorraine region of France. Private Enright and two other soldiers were massacred and buried near the battlefield. His body was retrieved and he was reburied with military honors in this grave at St. Mary's Cemetery in Lawrenceville on July 16, 1921. (Author's collection.)

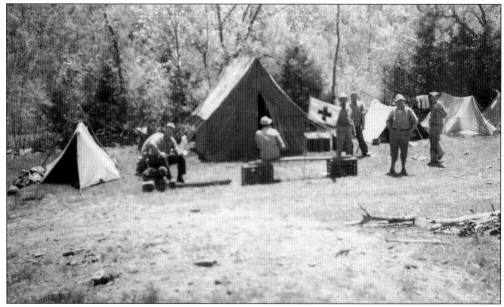

Soldiers relax in front of a medical aid station at Camp Forrest, Tennessee, on February 5, 1943. Camp Forrest was a training center for the reactivated 80th Infantry Division, which later participated in major battles in France, Luxembourg, and Germany. Many Irish Pittsburghers were attached to the 80th, including John McElligott (far right). (Courtesy of McElligott family.)

The seven Feeney siblings pose here in the mid-1940s. William (second row, left) and Edward (second row, far right) served in the US Army. Frank, in the middle, was a civilian. Their sisters in the front row are, from left to right, Eileen, Alice, Kathleen, and Claire. (Courtesy of Anne Feeney.)

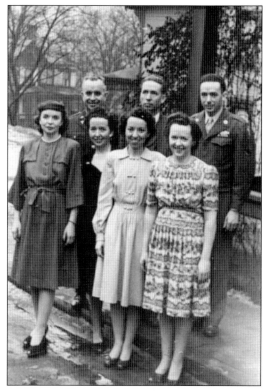

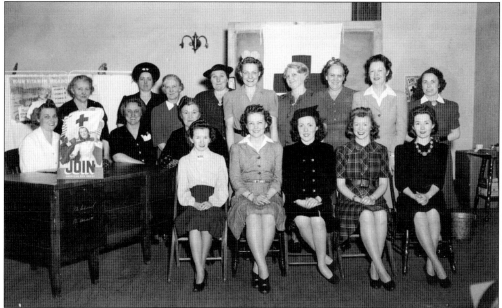

Citizens were active on the homefront during World War II. The American Red Cross sent thousands of nurses overseas, organized blood drives, began a blood collection service to aid the wounded, and sent food packages to prisoners of war. Here, women pose during a local recruitment drive in the mid-1940s. Belle Hays, of Verona, is standing fourth from the right. (Courtesy of Hays family.)

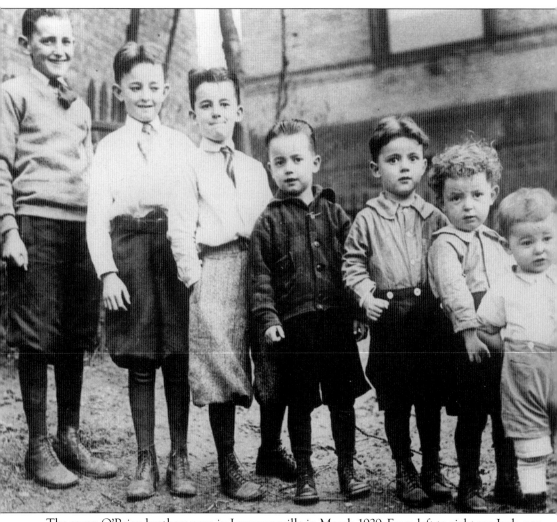

The seven O'Brien brothers pose in Lawrenceville in March 1929. From left to right are Jack, age 12; Shamus, 10; Lawrence, 8; Timothy, 5; Francis "Fats", 4; Bernard, 3; and Thomas, 2. There were also three O'Brien sisters and all of the siblings were the children of Morgan Joseph O'Brien and either Catherine Mary Murray O'Brien, who died in childbirth, or Morgan's second wife, Anne Reilly O'Brien. All seven brothers served in the armed forces during World War II. One of them, Lawrence, died, but not in action. (Courtesy of Timothy Daniel O'Brien.)

Timothy O'Brien, seen here in 1944, was one of the seven O'Brien brothers. He served in the 854th Aviation Engineer Battalion and built airstrips used by Allied aircraft in the Pacific Campaign. It was a dangerous job, as the construction crews worked in extreme heat and humidity and the Japanese bombed and strafed them on the job. (Courtesy of Timothy Daniel O'Brien.)

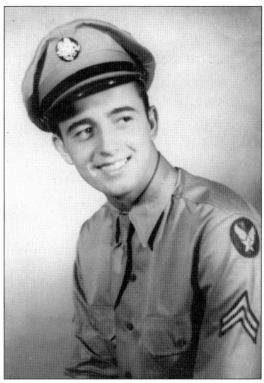

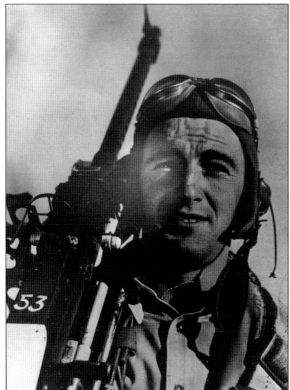

Lawrence O'Brien, seen here in his uniform in 1943, was the only one of the seven brothers to die. He was an Air Force tail gunner aboard a B-54 bomber that flew combat missions over Europe and his service earned him the Distinguished Flying Cross. Lawrence survived the war but died in an accident in Germany after he reenlisted. (Courtesy of Timothy Daniel O'Brien.)

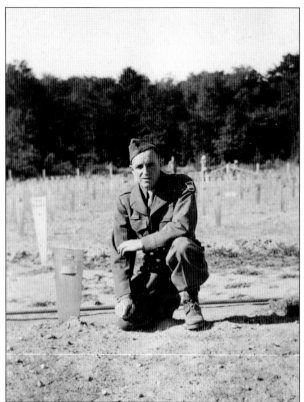

Many Irish Pittsburghers died in World War II. Here, in 1945, John McElligott kneels next to the simple grave of his brother, William McElligott, in Epinal American Military Cemetery in France. Families were given the option of having the bodies of their loved ones returned to the United States but William's widow, fearing that she would not receive her husband's remains, opted for burial in France, where he had been killed. (Courtesy of McElligott family.)

The burial of Sgt. Thomas Conroy, of Oakland, is seen below in India in June 1945. Sergeant Conroy died when he tried to save another man from drowning and received a hero's funeral service. The Army and Air Force stationed troops in India in a major initiative to defend China against Japanese invaders. (Courtesy of Mary Lou Conroy.)

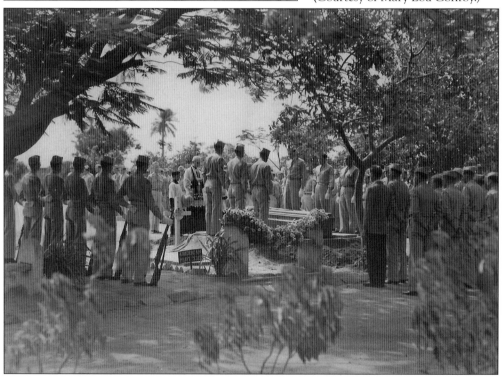

Robert Schmalstieg poses here in 1946 between his mother, Lucy Green Schmalstieg (left) and his sister, Leatrice (right), at their home in Terrace Village. He grew up in Morningside and enlisted in the US Navy on October 23, 1943, at the age of 17. He served in the Pacific Theater on a YTM 470, a medium-sized yard tugboat. (Courtesy of Schmalstieg family.)

Eddie Tighe served in the US Navy during the Korean War. (Courtesy of Patricia Moorhead.)

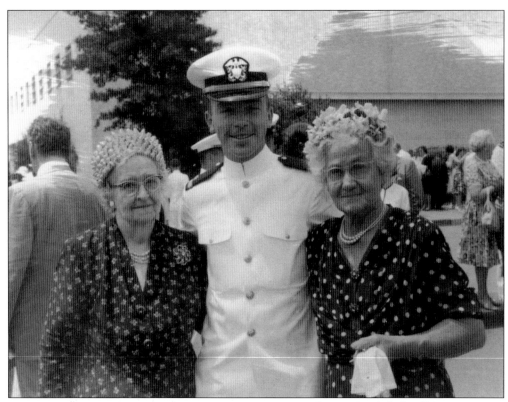

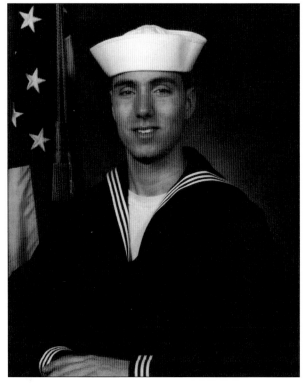

Dennis McCahill, of Monessen, is seen at his graduation from the United States Naval Academy in Annapolis, Maryland, in 1962. He is celebrating with his grandmothers, Barbara McCahill (left) and Mary Nanns Feeney (right). McCahill passed rigorous courses in naval science, engineering, and navigation as well as leadership, ethics, and military law. After graduation he was commissioned as an ensign in the Navy. (Courtesy of Anne Feeney.)

The armed forces continue to be a viable career path for Irish Pittsburghers. PO2 James J. Schafer, who grew up in Monroeville, served in the US Navy from 1997 to 2002. Stationed in Norfolk, Virginia, Schafer was a radioman on submarines. He is seen here in 1997 after his graduation from basic training. (Courtesy of Cantwell family.)

Seven
PERSONALITIES
"A TRIUMPH FOR IRISH AMERICANS"

Kennedy's presidency was a triumph for Irish Americans,
signaling their final arrival and acceptance in a land where, for so long,
their name and their religion were held against them.

<div align="right">

The Irish Americans
Jay P. Dolan

</div>

John F. Kennedy's election to the presidency was a peak experience for Irish Americans, vindication for all that their ancestors had suffered, and proof that their assimilation could lead to triumph. Pittsburgh has produced its share of accomplished people, locally and nationally. Irish Pittsburghers dominated municipal government, with David Lawrence's ascension from Democratic boss to the governorship marking the apogee of political power and influence in Pennsylvania.

 Highland Park's Gene Kelly danced on stage and screen. East Liberty's Billy Conn won the light heavyweight championship. McKeesport's Marc Connelly won the Pulitzer Prize for his play *The Green Pastures*. North Side's Art Rooney famously bought the Pittsburgh Steelers with money he won at the racetrack. Danny Murtaugh managed the Pittsburgh Pirates to their 1960 and 1971 World Series championships. Irish-born Mother Frances Warde founded Mercy Hospital, the first hospital in the region. Other Pittsburghers lit the way with their musical talent, wisdom, and joie de vivre.

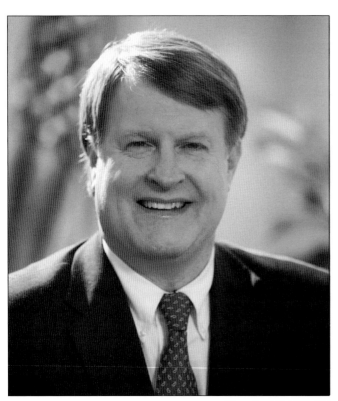

Irish Pittsburghers retained a strong presence in the political community with the 2011 election of Rich Fitzgerald as Allegheny County chief executive. Born and raised in Bloomfield, Fitzgerald attended St. Lawrence O'Toole Grade School, Central Catholic High School, and Carnegie Mellon University. After a stint as a businessman, he represented District 11 on the Allegheny County Council from 2000 to 2011, serving as council president from 2004 on. As county executive, he has focused on regional economic development and job creation. (Courtesy of Rich Fitzgerald.)

Christopher Magee (1848–1901) was a Republican political boss in Pittsburgh who, along with William Flinn, built a powerful political machine in the late 1800s. Magee and Flinn changed the city charter to allow department heads, rather than city council, to make appointments, consolidated Republican control of the city and Allegheny County, and curried favor with big business that allowed them to develop a widespread system of patronage. (Courtesy of McElligott family.)

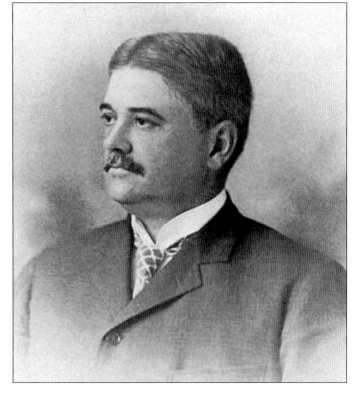

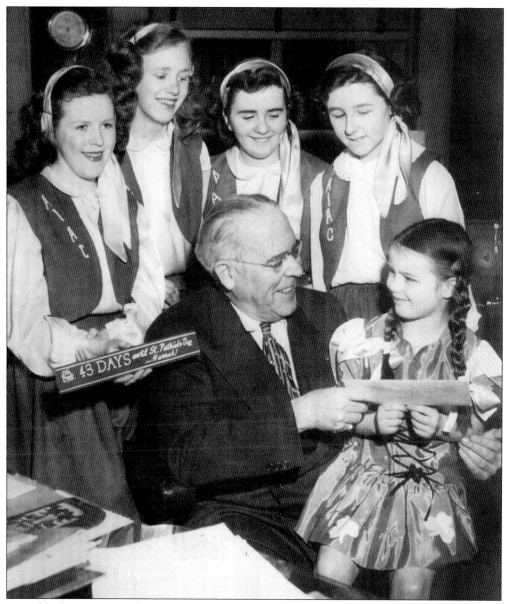

Arguably the most powerful politician to emerge from Pittsburgh, David L. Lawrence (1889–1966) was the grandson of Irish immigrants and grew up in the Point. So many Irish immigrants crowded into the neighborhood that residents were called "Point Irish." Life in this slum, where people lived chock-a-block with industry and a railroad, gave the future mayor firsthand knowledge of the struggles of the poor. Lawrence became involved in party politics early, building a potent Democratic machine in the 1920s and 1930s. During his time as mayor, from 1945 to 1958, he engineered the Pittsburgh Renaissance with Richard King Mellon and other corporate leaders. Lawrence served as the first Catholic governor of Pennsylvania from 1959 to 1963. Here, in February 1947, Mayor Lawrence is seated with a young dancer from New York on his lap. Behind them are local dancers from the All Ireland Athletic Club, from left to right, Theresa Reaney (later Sister Mary Faith), Mary Jane Conley, Mary Eileen O'Shea, and Mary Catherine Farrell. (Courtesy of Eileen Aquiline.)

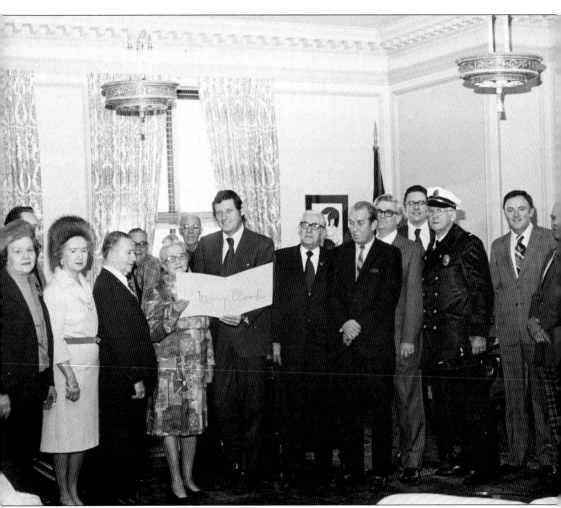

Peter Flaherty (1924–2005), seen here planning the 1976 bicentennial with local Irish leaders, served as Pittsburgh's mayor from 1970 to 1977 and as Allegheny County commissioner from 1984 to 1996. A powerhouse who bucked the Democratic machine to run for mayor as "Nobody's Boy," Flaherty gained a national reputation for his community-minded reforms, including battling special interest groups, cutting taxes, and trimming the city payroll. He later ran unsuccessfully for the US senate and for governor of Pennsylvania and served briefly in the US justice department during Pres. Jimmy Carter's administration. (Courtesy of M.F. Garrison.)

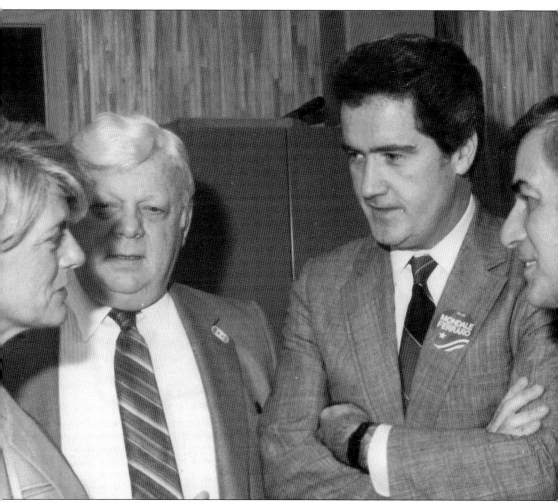

Congressman William J. Coyne of Greenfield was a Democratic member of the US House of Representatives for District 14 from 1980 to 2003. Wearing a Mondale/Ferraro campaign button during the 1984 presidential campaign, Congressman Coyne (second from right) poses with, from left to right, Geraldine Ferraro, the Democratic vice-presidential candidate; John Connelly, the owner of Gateway Clipper Fleet; and Pittsburgh mayor Richard Caliguiri. (Courtesy of Schmalstieg family.)

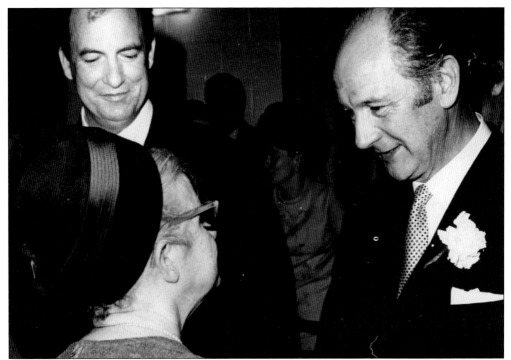

Irish Pittsburghers maintained close political ties with Ireland. Jack Lynch (1917–1999) was the prime minister, or *taoiseach*, of the Republic of Ireland from 1966 to 1973 and from 1977 to 1979. He is seen here on the right during his 1969 visit to the city to attend the dedication of the Irish Centre of Pittsburgh. (Courtesy of Irish Centre of Pittsburgh.)

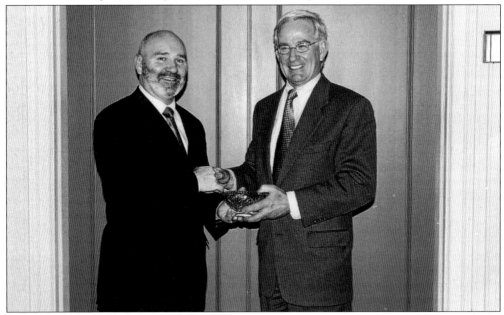

Alex Maskey (left), Lord Mayor of Belfast in Northern Ireland, presents an Irish crystal bowl to Pittsburgh mayor Tom Murphy during a visit to the city in February 2003. (Photograph by Carmen J. DiGiacomo.)

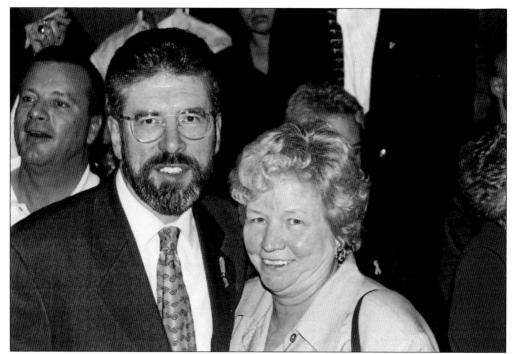

Gerry Adams, the president of Sinn Fein, visited Pittsburgh in October 1996, two years before the Good Friday Accords ended sectarian violence in Northern Ireland. Standing on the left, Adams is flanked by supporters, including Norma Jean Reilly. (Photograph by Carmen J. DiGiacomo.)

In 1993, a blizzard struck the city on St. Patrick's Day but the parade went on. Chuck Peters, seen here in 2011, and fellow revelers from the South Side could not get home, so they repaired to a saloon to wait out the storm in comfort. While there, they created the South Side Celtic Society. The group now celebrates its founding with a reviewing stand at the parade and a "hooley," or party, afterward. (Courtesy of South Side Celtic Society.)

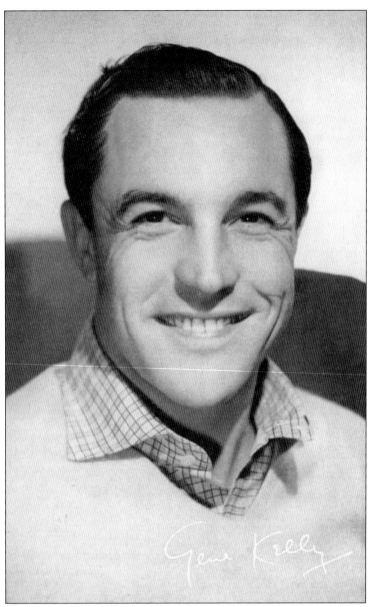

Eugene Curran Kelly (1912–1996), better known as Gene Kelly, was an innovative dancer, choreographer, actor, singer, and director. He grew up in Highland Park and graduated from the University of Pittsburgh in 1933. Kelly appeared in local recitals and ran two dance studios before he left for New York City in 1938. In 1940, he starred in the Broadway production of the Rodgers and Hart musical *Pal Joey*. Metro-Goldwyn-Mayer brought him to Hollywood in 1942, where he made his film debut in *For Me and My Gal*. Kelly brought a new athleticism to musicals like *Cover Girl*, *On the Town*, *Anchors Aweigh*, and *The Pirate*. As star and choreographer of *An American in Paris*, he broke new ground with his 13-minute ballet featuring the title song, and the film won the Academy Award for Best Movie of 1951. *American in Paris* was considered Kelly's masterpiece, but its reputation was later eclipsed by *Singin' in the Rain* (1952), Kelly and Stanley Donen's lighthearted tribute to early screen "talkies." Filled with dazzling numbers, *Singin'* is capped by Kelly's iconic dance on a rain-soaked street. (Courtesy of McElligott family.)

Anne Feeney of Swissvale is seen here at her first public performance on October 15, 1979, at the Moratorium against the War in Pittsburgh. Feeney is a longtime musician and activist who has performed all over the United States and Europe. She was the first and only female president of the Pittsburgh Musicians' Union and a founder of Pittsburgh Action Against Rape and the Women's Bar Association of Allegheny County. (Courtesy of Anne Feeney.)

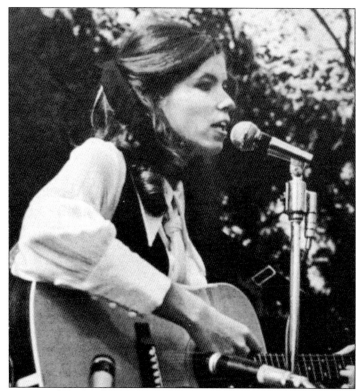

Mary Virginia Kelly (1924–2012) of Shadyside enjoyed a 48-year career with the City of Pittsburgh, lastly as an administrator for the zoning board of adjustment. When she retired on December 31, 1995, the day was proclaimed "Virginia Kelly Day" by the city council. The chair of the Seventh Ward Democratic Committee and a lifelong supporter of the Democratic Party, Kelly was known for her courage, vivacity, and Irish wit. (Courtesy of Schmalstieg family.)

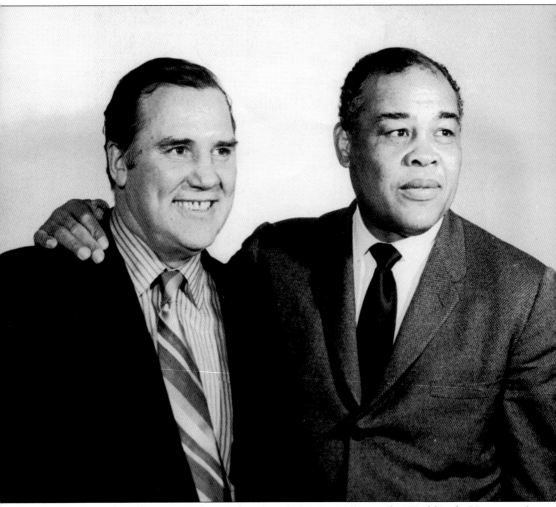

William David "Billy" Conn, "the Pittsburgh Kid" (1917–1993), was the World Light Heavyweight Champion from 1939 to 1941. Born in East Liberty, Conn had a 64-12 career record. On June 18, 1941, he fought Joe Louis—seen here on the right with Conn in their later years in the 1970s—for the heavyweight championship. Louis outweighed Conn by more than 25 pounds but Conn remained ahead on the scorecards going into the 13th round. He tried for a knockout, but instead, Louis knocked him out and retained the title. When Conn was asked why he tried to knock Louis out rather than play it safe and win on points, he said, "What's the use of being Irish if you can't be thick[headed]?" A rematch between Conn and Louis was planned but Conn broke his hand in a fight with his father-in-law and the bout was postponed. By the time Conn's hand healed, Louis had joined the Army and put his boxing career on hold. Conn was inducted into the International Boxing Hall of Fame in 1990. (Courtesy of John Haltigan.)

Jim O'Brien, an author and columnist for the *Valley Mirror*, has enjoyed a long career in sports writing and reporting. He wrote the *Pittsburgh Proud* series of books about the city's great sports teams and personalities, including *The Chief: Art Rooney and His Pittsburgh Steelers*, *Lambert*, and *Always a Steeler*. In this 2010 photograph, O'Brien stands in front of a Walter Iooss Jr. photograph of boxing champions Muhammad Ali and Joe Frazier. Raised in Hazelwood, O'Brien has fond memories of St. Stephen's Catholic Church and Grade School. The pastor, the Rev. Dennis Murphy, would bring his dog Sassy on his visits to O'Brien's classroom. Father Murphy would lean down and act as if the dog were saying something to him, then stand up and tell the children that Sassy wanted to remind them to say their prayers and brush their teeth every morning. The students believed every word of it, at least until they reached the fourth or fifth grade. (Courtesy of Jim O'Brien.)

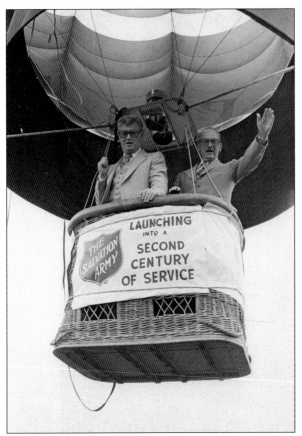

David F. Figgins of the North Side was president, chairman, and CEO of the general contracting firm Mellon Stuart and an extraordinary volunteer throughout his career. Born in Belfast, he graduated from Queens University and immigrated to Canada, where he worked for a consulting firm. He was lured to Pittsburgh by Mellon Stuart. Under Figgins's leadership, the firm oversaw the expansion of Allegheny Hospital. Figgins was a founding member of five organizations and served on more than 25 boards, including the Three Rivers Rowing Association, River City Brass Band, the Pittsburgh Tissue Engineering Institute, the Gaelic Arts Society, and the Irish Centre of Pittsburgh. In the photograph at left, Figgins (left) celebrates the Salvation Army's centennial as a member of its national advisory board on May 12, 1980. Below, Figgins, who was president of the Pittsburgh Rotary Club, addresses the Rotary International in 1976. (Both, courtesy of David F. Figgins.)

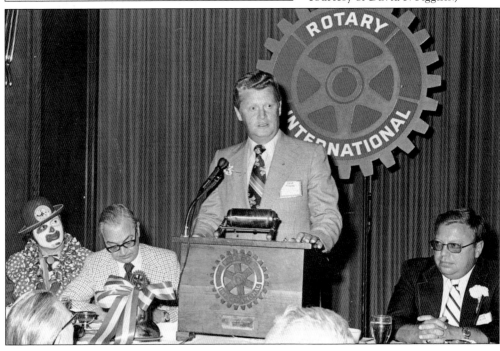

Mary Stack Clark, the cofounder of the Irish Centre of Pittsburgh, was born in Duag in County Kerry in 1905, the oldest of 10 children. When she immigrated to the United States in 1926, her family held an "American wake," a mock funeral for their beloved daughter because they knew they would never see her again. Fortunately, she did return home for a visit later in life. Seen here in 1927, Clark worked as a secretary throughout the Great Depression, married Francis Clark in 1939, and raised their daughter, Mary Frances, in Wilkinsburg. Heavily involved in community life, she was an effective voice for the propagation of Irish culture throughout the region. Active in the Gaelic Arts Society and the Pittsburgh Irish bicentennial, she also volunteered with the Girl Scouts, the Western Pennsylvania School for the Deaf, and the Swissvale and Wilkinsburg Democratic ward committees. (Courtesy of M.F. Garrison.)

At left, Pittsburgh City Council Member Bob O'Connor (1944–2006) presents a Certificate of Mayoral Commendation to Tamar Krishnamurti and Peter Haven for participating in a cleanup program at St. Bede's Catholic School in Point Breeze on October 21, 1993. O'Connor, who was from Squirrel Hill, was later elected mayor of Pittsburgh and took office on January 3, 2006. Tragically, he died of a rare brain cancer after serving only eight months. O'Connor was known as "the people's mayor" and is remembered for his "Redd Up" campaign to clean up the city. (Courtesy of Diocese of Pittsburgh Archives and Records Center.)

BIBLIOGRAPHY

Clark, Dennis. *The Irish in Pennsylvania*. University Park, PA: Pennsylvania Historical Association, 1991.
Cordell, Alexander. *Race of the Tiger*. London: Coronet Books, 1963.
Davenport, Marcia. *The Valley of Decision*. Pittsburgh, PA: University of Pittsburgh Press, 1942 and 1989.
Diner, Hasia R. *Erin's Daughters in America: Irish Immigrant Women in the Nineteenth Century*. Baltimore, MD: Johns Hopkins University Press, 1983.
Dolan, Jay P. *The Irish Americans*. New York: Bloomsbury Press, 2008.
Giesbery, Judith. "Explosion at the Allegheny Arsenal." www.historynet.com. April 13, 2010.
Kleinberg, S.J. *The Shadow of the Mills: Working Class Families in Pittsburgh, 1870–1907*. Pittsburgh, PA: University of Pittsburgh Press, 1989.
Maloney, Margaret E. *Fag An Bealach: The Irish Contribution to America and in particular to Western Pennsylvania*. Pittsburgh, PA: United Irish Societies Bicentennial Committee of Western Pennsylvania, 1977.
McCaffrey, Lawrence J. *The Irish Diaspora in America*. Bloomington, IN: Indiana University Press, 1976.
Scranton, Philip. "Father Cox, Andrew Mellon and a Huge March on Washington: Echoes." *Bloomberg View*. January 10, 2012.
Various Sources, 1843–1917. *Memoirs of the Pittsburgh Sisters of Mercy*. New York: Devin-Adair Company, 1918.
Weber, Michael P. *Don't Call Me Boss: David L. Lawrence, Pittsburgh's Renaissance Mayor*. Pittsburgh, PA: University of Pittsburgh Press, 1988.

Discover Thousands of Local History Books
Featuring Millions of Vintage Images

Arcadia Publishing, the leading local history publisher in the United States, is committed to making history accessible and meaningful through publishing books that celebrate and preserve the heritage of America's people and places.

Find more books like this at
www.arcadiapublishing.com

Search for your hometown history, your old stomping grounds, and even your favorite sports team.

Consistent with our mission to preserve history on a local level, this book was printed in South Carolina on American-made paper and manufactured entirely in the United States. Products carrying the accredited Forest Stewardship Council (FSC) label are printed on 100 percent FSC-certified paper.